CELTIC DESIGNS

DEDICATION

This book is dedicated to the remote, unspoilt places in Scotland, Wales, the West of England and Canada in which I have had the privilege to live and carry out my work.

All my colour paintings are created using acrylic and gouache paints, with Chinese ink to accentuate the predominant black lines and features. There is an almost flamboyant brightness about acrylic and gouache paints, which to me is an integral part of Celtic art. Bright colours were not only used by the illustrators of the Great Gospels, but also very much by the La Tène European Celts from the fifth century BC onwards, especially in their enamelwork.

Further books of interest associated with the artist:

Celtic Connections
The Ancient Celts, Their Tradition and Living Legacy
David James and Simant Bostock; Blandford, 1996

The Celtic Image
Courtney Davis and David James;
Blandford, 1996 (Hardback); 1997 (Paperback)

Celtic Crafts – The Living Tradition
Edited by David James; Blandford, 1997

CELTIC DESIGNS

An Arts and Crafts Source Book

David James

A BLANDFORD BOOK

First published in the UK 1997 by Blandford
Cassell & Co.
Wellington House
125 Strand
London WC2R OBB

Copyright © 1997 David James
Reprinted 1998, 1999

Distributed in the United States by Sterling Publishing Co., Inc.,
387 Park Avenue South, New York, NY 10016-8810

A Cataloguing-in-Publication Data entry for this title is available from
the British Library

ISBN 0-7137-2688-1

Designed by Carole Perks

Printed and bound in Great Britain by
Hillman Printers (Frome) Ltd, Somerset

CONTENTS

FOREWORD

David James is an artist whose work I have admired for many years.
With a genuine understanding and feeling for the great Celtic traditions of
the British Isles, he is able to draw inspiration from the wealth of
outstanding ancient works, and produce brilliant new designs which
definitely belong to our own age.
His own work in turn inspires others, which is as it should be, and has
contributed much to the recent revival of interest in Celtic art.
This volume presents some of David James' best work from the past twenty
years, and will be a source of inspiration for many years to come.

Rhiannon Evans
Tregaron, 1997

RHAGAIR

Yr wyf wedi edmygu gwaith yr arlunydd David James ers nifer o
flynyddoedd.
Mae ganddo ddealltwriaeth a synwyr arbennig o gelfyddyd Geltaidd
traddodiadol ynysoedd Prydain sy'n ei alluogi i dynnu ar y cyfoeth o
weithiau mawr hynafol am ei ysbrydoliaeth a chreu cynlluniau newydd sbon
sy'n perthyn yn ddi-os i'n hoes ni.
Mae ei greadigaethau yntau yn eu tro yn ysbrydoli eraill, fel sy'n gymwys, ac
y mae ei waith wedi cyfrannu'n fawr at yr adfywiad diweddar mewn
celfyddyd Geltaidd.
Yn y gyfrol hon cyhoeddir rhai o'r goreuon o weithiau David James dros yr
ugain mlynedd ddiwethaf, gweithiau a fydd yn parhau i ysbrydoli am
flynyddoedd lawer i ddod.

Rhiannon Evans
Tregaron, 1997

INTRODUCTION

I have now been creating Celtic designs and applying them to various different kinds of craftwork for over twenty years. It is my hope that this book will inspire others to discover the enjoyment of creating their own designs and to use them in enhancing the beauty of their craftwork.

My fascination with Celtic designs began at an early age. I left the UK education system at the age of eighteen, and worked for a winter in Scotland on the island of Iona in the Inner Hebrides. At this time Dr George MacLeod, the pioneer founder and reconstructor of the present-day Iona Community, was living much of the time on the island.

One day he asked me to take plain white postcards and a waterproof pen, and to spend some time re-writing the very faded labels in the small island museum. In the end, I spent a good part of each day there for over a fortnight, not just copying the nearly illegible labels – which described and dated the ancient carvings – but also exploring the fascinating designs on the ancient stones, and sketching some of the simpler ones. In addition to the early Celtic material, there were also a couple of very intricate and beautiful eleventh-century Norse carvings, complete with Viking ships, which very much fired my imagination.

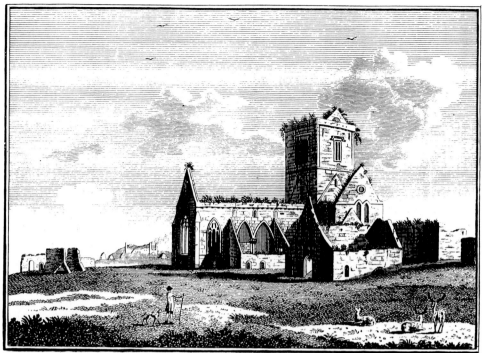

The CATHEDRAL, *in the* ISLE *of* JONA. *Eastgate sculp.*

Published according to Act of Parliament by Alexr Hogg, No 16, Paternoster Row.

Much of the completely rebuilt Abbey on the island bears testament to Dr MacLeod's extraordinary life's work. The steel engraving illustrated is of the derelict Iona Abbey in 1772. I bought the original picture in a junk shop in the 1970s for the princely sum of fifty pence, along with another of Oronsay Priory with the same date. They both measure 14 by 9 inches and it would be interesting to know whether the deer in the bottom right-hand corner were added as 'artistic licence', or if they actually lived on the island at that time — for there are certainly none there today.

The days working in the Iona museum were my first introduction to Celtic designs 'first hand', and the essence of that fortnight has never left me. I became absorbed with the intricate and elaborate patterns, and soon discovered some very old books in the Abbey library. These contained steel engravings of Celtic crosses and carvings from Scotland and Ireland. After spending many afternoons examining the highly detailed images, and carefully tracing a few of the more basic ones, I was 'hooked', and my intense fascination and love of Celtic designs is still with me today, over thirty years later.

Just before leaving the island to head back south again, I was having a talk with an elderly islander, Calum, with whom I had become very friendly during the time I was working there. I was musing on whether I would ever return to the west coast of Scotland, with its stunning beauty.

'Och, have ye no heard the old saying?' said Calum emphatically. 'Once ye've spent a night in Argyll ye'll always return!'

This proved to be absolutely correct, but ten years were to pass before it actually happened. In the interim, I spent a while living in south Wales,

helping friends to rebuild an old cottage remotely situated in the hills not far from Lampeter.

This was an ideal location for exploring Celtic and earlier sites in the region, and we visited various places: Nevern, with its wealth of Celtic associations, including Ogham carvings and the tenth-century Great Cross; the Celtic cross at Carew; the cathedral at St David's; St Non's sixth-century chapel within a stone circle; the megalithic cromlech at Pentre Ifan, with its massive capstone which weighs over 40 tons; and a number of other other intriguing sites. All these places served to further my interest in the Celtic world, and I was especially fascinated by the designs on the large, free-standing crosses.

From Wales, I travelled to the Findhorn Community in Morayshire, in eastern Scotland, where I stayed for several months working as a potter. While there, I had the chance to visit some of the ancient Pictish carvings in the area, such as the Sueno stone in Forres, with its intricate knotwork patterning and battle-scene depictions.

The west coast of Scotland soon began to exert its influence again. Thus, in the mid-1970s, together with my then partner and two other artistically minded folk, I moved to a dilapidated traditional Scottish farmhouse in a very remote location up in the hills four miles from Campbeltown, on the Kintyre peninsula, then in Argyllshire.

This proved to be the *real* starting point for my Celtic design work. The environment was filled with wonderful Celtic sites to visit, as well as earlier Bronze Age and megalithic monuments. There was no glass in the bathroom window of the farmhouse when we arrived, as well as no working toilet or bath. Having fixed the plumbing, we replaced the window with a single sheet of plate glass and were delighted to discover that, on the first cloud-free sunny day (a rarity in that area!), the coast of Ireland, with Rathlin Island and the Mountains of Antrim behind, was clearly visible.

It was while living in Kintyre that I first encountered George Bain's remarkable book on the geometric construction of Celtic designs. This came about in rather a strange way, as I had become friendly with the young local librarian in Campbeltown. Good fortune had it that he too was an avid enthusiast of Celtic and earlier sites and cultures. Having ascertained that I was the sort of person who would respect and look after books, he lent me many unique items from the library archives. These were usually passed across the counter in a brown-paper bag, with a wink and a 'thought you might like this one, Dave, just return it when you've finished it'.

That was over twenty years ago and he has long since left the area, but bless you, Norman, you lent me so much invaluable material to help my quest! Every book was carefully and gratefully returned in its brown-paper bag, with no-one the wiser except Norman and myself. Judging by the thick dust on many of them, they had been *in situ* for decades — some were nineteenth-century publications so nobody would have noticed anyway.

One small series of books were the very rare original volumes by George Bain on the construction of Celtic designs, originally produced as a series in landscape (lengthwise) A5 format for Scottish schoolchildren.

There are many Celtic sites in Kintyre and the surrounding area, and these provided much inspiration. There's nothing like seeing (and touching) an ancient Celtic carving to get the artistic adrenalin going! We visited places such as the sixth-century chapel at Kilbrannan, the Celtic crosses at Campbeltown, Kilmory, and Keills, carvings at Saddell, Kilmartin and various other sites, such as the enchanting St Columba's cave at Ellary, near Tarbert.

On a previous visit to Scotland, before actually living there, I had spent some time on the Isle of Skye, with its magnificent scenery. On one particular afternoon I found myself on the southwest tip of the island and decided to climb as far as I could up a small mountain which overlooked the western sea. The sun was just setting over the Isle of Rhum, which looked like a small, dark purple Christmas pudding rising from an unusually calm sea. To the north of this, the small island of Canna was clearly visible and seemed to hold a magic all of its own. This was one of the finest sunsets I've ever seen, and is why I have been a little preoccupied in this book with a particular design from a fragment of an early Celtic cross shaft discovered on Canna. The beauty of this complex design to me reflects the magical beauty of Canna and the Inner Hebrides.

I had been a reasonably competent potter since the early 1960s, so while living in Kintyre I started to experiment with transferring some Celtic designs onto large plates, carving the patterns through a thin coating of white slip onto red earthenware clay. These proved very successful, but also very time-consuming; and I could never keep up with the demand for them, even though they were most satisfying to carry out.

Also while in Kintyre, I started using some of my own designs for greetings cards. Looking back on these, they were rather basic, mostly printed in black on coloured paper, yet they proved popular and craftshops sold them both locally and further afield. I recall being very excited at receiving my first order for cards from a shop in Germany at that time in 1977.

The Aviemore Trade Fair in what was then Invernesshire, held every autumn, proved to be a mecca for craftworkers of all types. In 1978 I attended the event, displaying some copper enamel dishes, pendants and lidded boxes which I had made, using a technique of hand-cut stencils to transfer some of the simpler Celtic designs onto the items. I had brought the enamelling kiln to Scotland with me, having practised this craft several years before in the south of England, using both copper and silver, and on rare occasions gold. Celtic enamelwork seemed to be appreciated and we sold a number of pieces.

It was from that farmhouse in Kintyre in 1977 that I sent some of my first colour designs to a publishing company in Stornoway, on the Isle of Lewis in the Outer Hebrides. The proprietor liked them and came down to

the farmhouse to check out more of my work. The outcome was that, after approval by the authorities of the Highlands and Islands Development Board I was given a grant by them to enable a hardcover book to be published containing the designs, together with a text relating to Celtic carvings of the Argyll area. The book was published in 1978 as *Celtic Art – The Carved Stones of Western Scotland* and sold 4000 copies in a relatively short time, before the publishers ceased operating soon afterwards. The colour designs, however, were sold to a publisher in California who used them very effectively in a large-format colour calendar for 1979. One particular design, which was also the cover illustration of the book *The Carved Stones of Western Scotland*, was considerably more elaborate than the rest and I have included a black and white version of it in this book.

In 1979 I moved back to the south of England but, as those who have had any experience with Celtic designs will testify, once you've started creating your own, it almost becomes a way of life, and I had no intention of discontinuing my work after the move.

Interestingly, after moving south, I found the work increased in various directions and also in different media. As well as writing articles and creating illustrations for magazines, I was also offered commissions by people who were attracted to the complex Celtic patterns.

In the autumn of 1981 I moved with my family to a thatched cottage about half a mile from the foot of Eggardon Iron Age hill fort in west Dorset, and lived there for eight years. The cottage was built in the early 1700s and set in a remote little hamlet. There was a massive Irish yew tree in the garden, which was certainly as old as the cottage, possibly older. Also in the garden was a well, which in the early part of this century had been used as the water supply.

Here, with friends, we built a cedarwood workshop at the bottom of the garden, and I was able to use this as a design studio for several years. I also carried on with my pottery in this workshop, and included as many Celtic pieces as time would allow.

I started exploring pyrography – which is the burning of designs onto wooden items using a very fine, electrically heated metal point. This proved to be an excellent and different way of transferring Celtic designs onto three-dimensional shapes, and I worked with lidded boxes, large platters, wooden bowls, plaques and smaller plates.

Pyrography fascinated me, and I worked hard to produce a wide range of items. Part of the mystique of this craft is the smell while one is working – reminiscent of late autumn bonfires with their smouldering leaves. With much help from my partner at the time, we sold the work to shops in this country, and also to two large Celtic shops in Brittany, owned by a renowned Breton musician and folklorist who has always been very enthusiastic about the Celtic world.

During this period I also carried out Celtic commissions when I had the time. One of the more unusual ones was from a lady in Northumbria, who wrote to me asking if I would design a large Celtic cross for her to embroider onto the back of a priest's robe. The priest lived in Ireland and she had undertaken to carry out the work on his behalf. I designed an unusual style cross (illustrated in my book *Celtic Crafts – The Living Tradition*, Blandford, 1997) which she embroidered by hand in gold thread, together with two small Celtic roundels for the front of the white robe. The whole procedure took her more than a year to complete, and I often think of her as someone with 100 per cent dedication to her work! It was good to hear afterwards that the Irish priest was delighted with the finished robe.

Other commissions at this time were for magazine and book covers, some of which are included in this book, and also silver jewellery designs for a London firm.

During that time I wanted to experiment with applying Celtic designs to as many different media as possible. Nowadays, twelve years later, I am happy to create original designs for specific craftworkers who have much more skill in their chosen fields than I have. The outcome is then beneficial to both of us.

In 1990, I left Yew Tree Cottage and went to live on my own in a very small chalet-style abode on a remote hillside in west Dorset, overlooking Chesil Beach. The little building was on private farmland, and had a wood-burning stove for heating and bottled gas for cooking.

I lived here for four years, and it was in this environment that my Celtic work really began to expand and grow. The owners of the farm and their friends were very interested in my work, and it was here that I met my present companion, Grace, who has given me a great deal of support and encouragement over the last few years. I worked here as a potter, using one of the outbuildings on the farm to house the sizeable kiln, and when not potting enjoyed creating some new Celtic designs, some of which are included in this book.

At the same time *Newyddion Celtica* (Celtica News), an excellent Celtic publication produced by the Welsh Tourist Board, ran a short feature on my new cards. I asked them to add a small paragraph at the bottom of the article, to the effect that if anyone was interested in discovering more about Celtic matters, I would be glad to correspond with them and share what I had learned over the years. Having by now become acquainted with a good number of Celtic artists, craftworkers and folklorists/historians, I added that, if I wasn't able to help them, it was likely that I would 'know a man (or often a woman) who could'.

I had only expected a few replies, so was amazed at the response. People wrote from as far afield as Russia, the Republic of China, Brazil, Saudi Arabia and Israel, as well as others from the USA, Canada, Australia, New Zealand, and most of the European countries.

Grace suggested that I should start a small magazine, and that a possible name for it could be 'Celtic Connections'. Thus, in 1992, the first issue of *Celtic Connections* was launched, produced on a battered old electric typewriter.

It has gone from strength to strength, and now, over four years later (February 1997), we are approaching issue number 18, and the magazine is produced on up-to-date computer equipment. We are now one of the only small magazines of this kind to employ a full-colour cover, and enthusiastic Celts subscribe worldwide, from Hawaii to Japan.

In 1994 I moved to a remote house in a tiny hamlet called Waddon, about four miles from Abbotsbury in west Dorset. All the places I have lived in have been remote; I find the countryside and its quietness a great help in maintaining a reasonably prolific output of work. Here there are singularly few distractions and disturbances (with the exception of visiting wildlife such as deer, foxes, birds of all kinds from merlins - to greater spotted woodpeckers, and a colony of glow-worms in the summer). I have continued the magazine, and have also written three illustrated colour hardback books for the Blandford imprint of Cassell. The first was with the artist Courtney Davis, who I had known for some time. His artwork is known in Celtic circles worldwide and it was enjoyable to write the book with his fine illustrations in it. It is called *The Celtic Image* (Blandford, 1996) and is now in its first reprint. The second book is entitled *Celtic Connections* (Blandford, 1996) and contains excellent colour photographs of Celtic, Iron Age, Bronze Age and megalithic sites and artefacts by the photographer Simant Bostock from Glastonbury. These photographs are coupled with a text by various subscribers to *Celtic Connections* magazine, as well as further text and colour artwork by myself.

The third book is entitled *Celtic Crafts – The Living Tradition* (Blandford, 1997). This contains colour illustrations and text by some of the finest Celtic craftworkers today, from the Outer Hebrides and the Orkney Isles, to the Isle of Man, Ireland, Wales, Cornwall and Brittany. There is additional text by myself, and this was a most enjoyable book to write. It also ties in well with this present book of Celtic designs suitable for craftwork.

Throughout my writing and design work, my companion Grace has been a loving friend and tremendous support. Her positive attitude to life, coupled with enthusiasm and a very clear and centred approach, have helped me a great deal and I shall always be extremely grateful for her astute perceptions (as well as the light-hearted sense of humour that we both share!).

Over more than twenty years it has been a delight for me to see how the appreciation of Celtic art and design has grown. Nowadays, Celtic art is accepted and loved by enthusiasts worldwide, and many people are trying their hand at creating their own designs from first principles, and also applying their designs to craftwork. To these people I would say 'go for it', and it is my hope that you will receive as much enjoyment from your work as I have.

ABOUT THE DESIGNS AND ARTWORK

I feel it is appropriate at this point to write a brief word about the designs in this book. I have found after many years of using Celtic designs on craftwork that it is a very good idea to take the design as far as a preliminary line drawing, and then to make several copies of it at that stage. I have included a number of 'before and after' versions in the book, using this method. Once you have a line drawing, you are then able to use the copies made from it at this stage to experiment with different colour-schemes, in order to discover the best for your own particular craft. This process is very useful for many different media, from straightforward colour paintings, to coloured dyes on leather, fabric-printing, painting onto wood, slate and other materials. By experimenting with the line-drawing copies it is also possible to gain at least some idea of the appearance of a textured finish on your particular medium. The line drawing can also be pierced with a craft-knife to make a stencil for use with enamelling, or used in conjunction with carbon paper to transfer the design onto harder materials such as wood, slate, stone or 'leather-hard' clay in order to leave a visible outline for carving. It will be your basic template for whatever medium you are working with.

May your Celtic crafts bring beauty to the planet at a time when it is much needed.

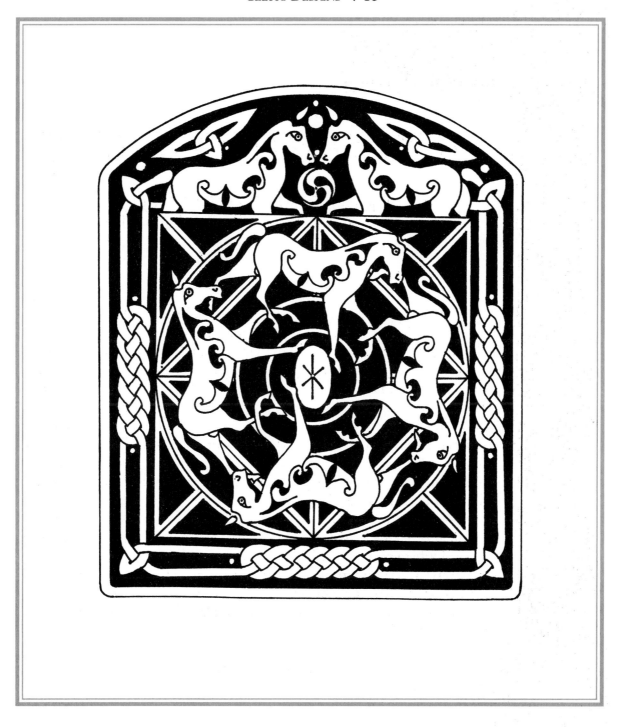

I Magazine cover design for *Meyn Mamvro - Journal of Ancient Stones and Sacred Sites in Cornwall* (1988).

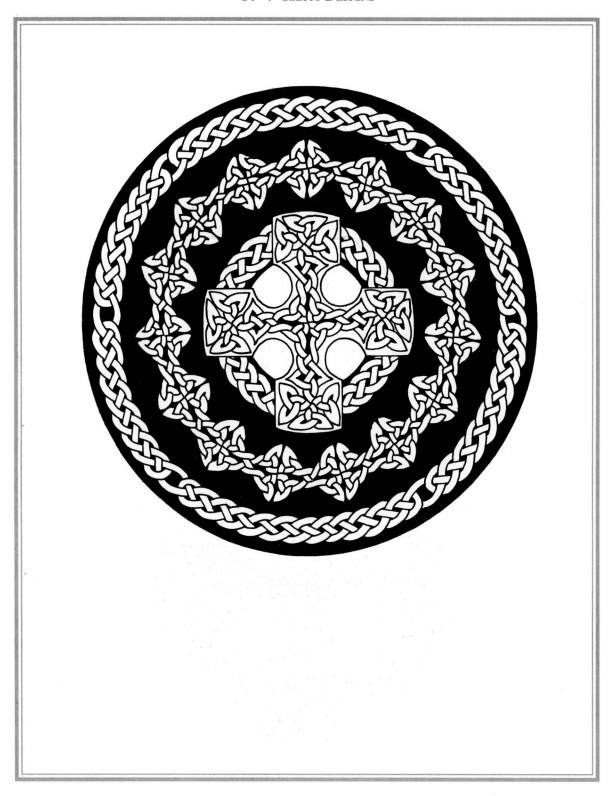

2 Basic design, used as a colour illustration in the book *Celtic Connections* (Blandford, 1996).

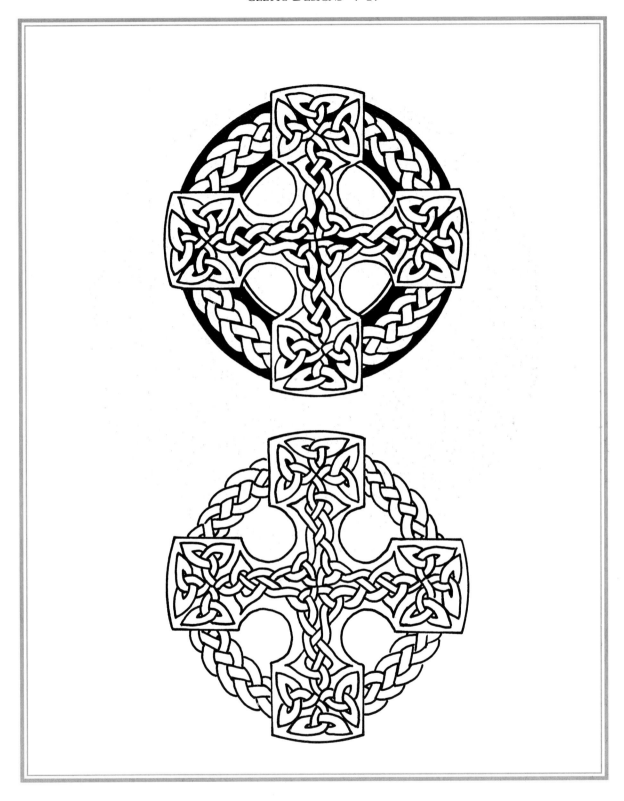

3 Enlargement of the centre section of the previous design, in solid format and line drawing.

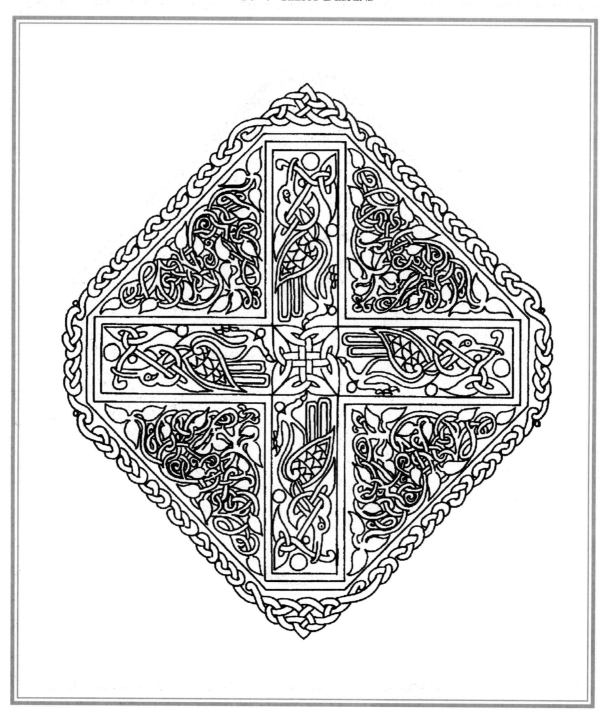

4 Preliminary line drawing for the following design.

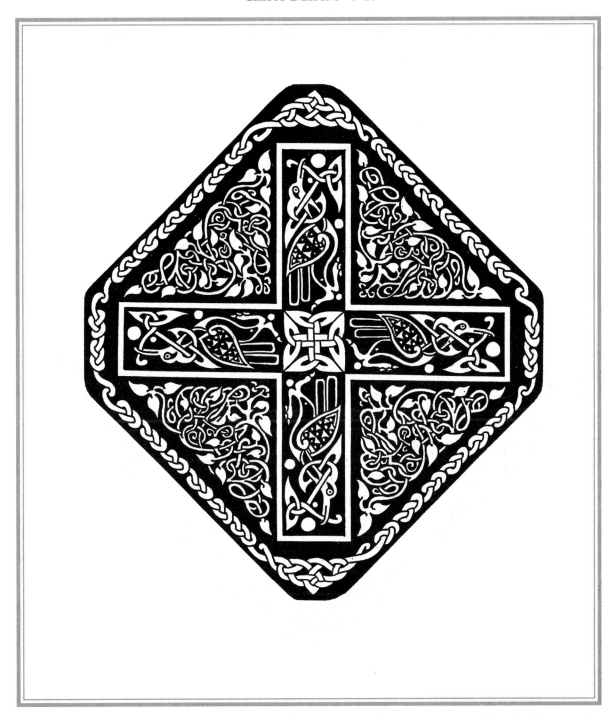

5 'Birds of Friendship', originally a colour painting, printed as a greetings card.

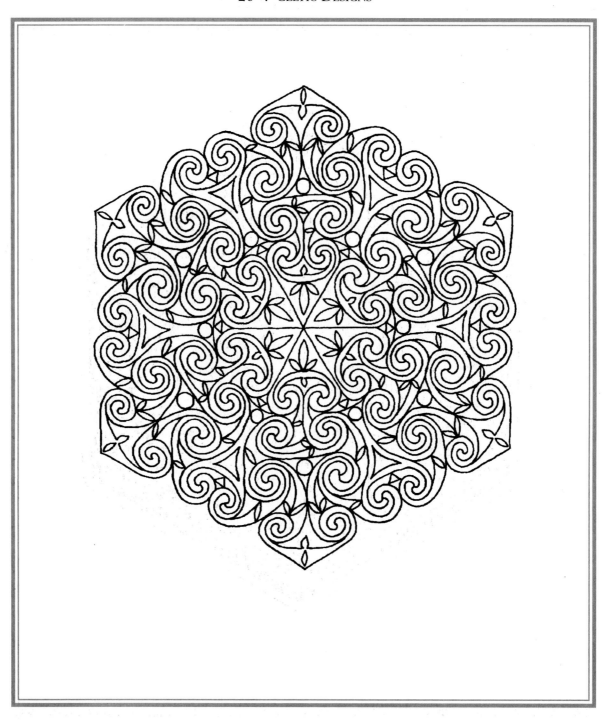

6 Preliminary line drawing for the following design.

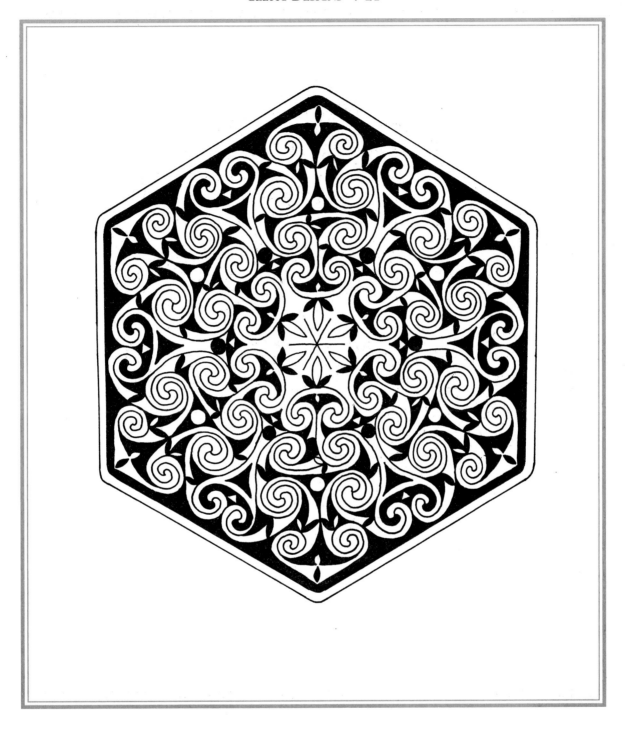

7 'Spirals Snowflake', a colour painting, printed as a greetings card; subsequently used by The Welsh Gold Centre in Tregaron as a coaster design, printed in gold on leather.

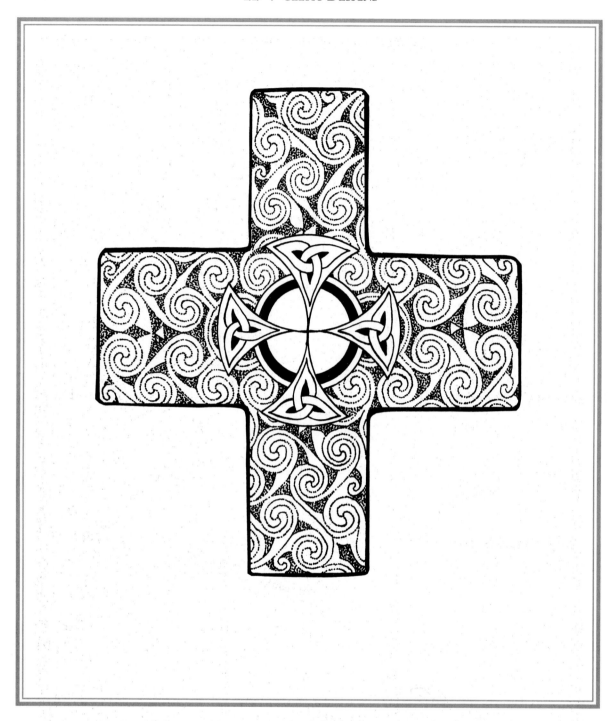

8 Detail of the central cross in the design opposite.

9 'Carpet and Cross' design used for a large elaborate painting; subsequently for use as a religious book-cover decoration.

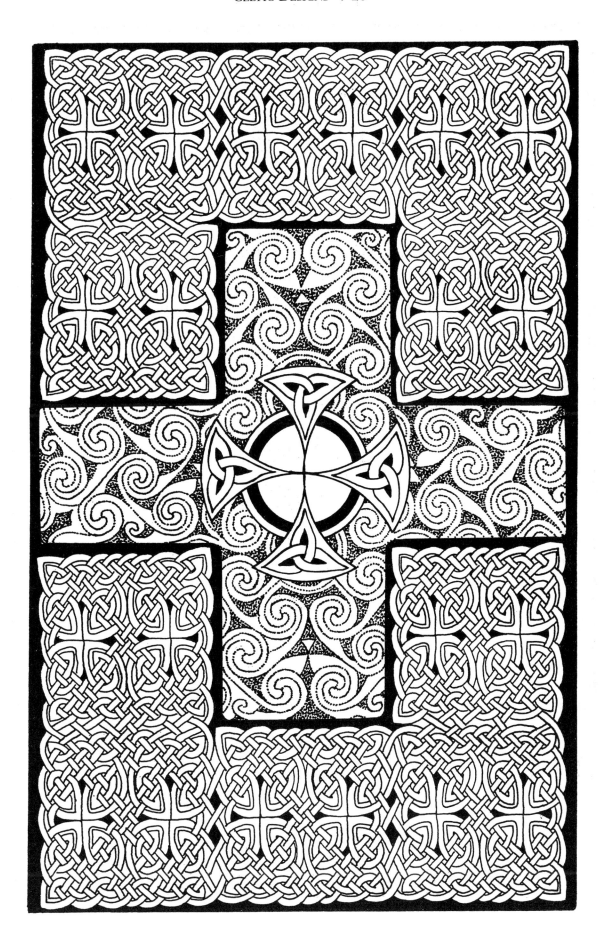

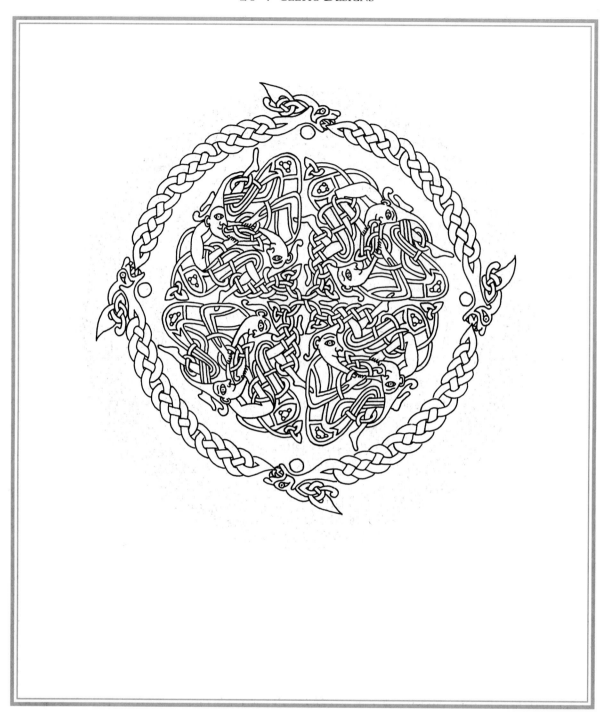

10 Preliminary line drawing for the following design.

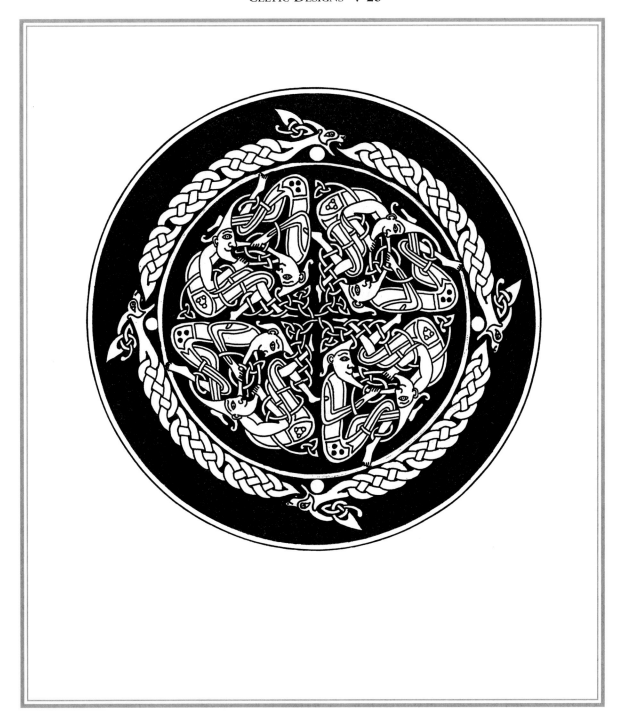

II 'Guardians of Humanity', a design used as the centrepiece for a
Harrogate Trade Fair exhibition (1986); burnt onto a very large
sycamore-wood platter using the technique of pyrography
(see introduction).

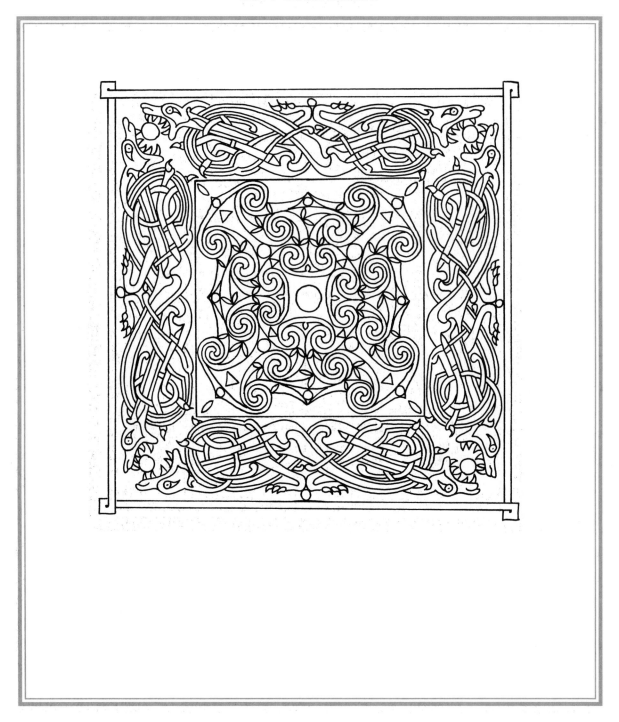

I2 Preliminary line drawing for the following design.

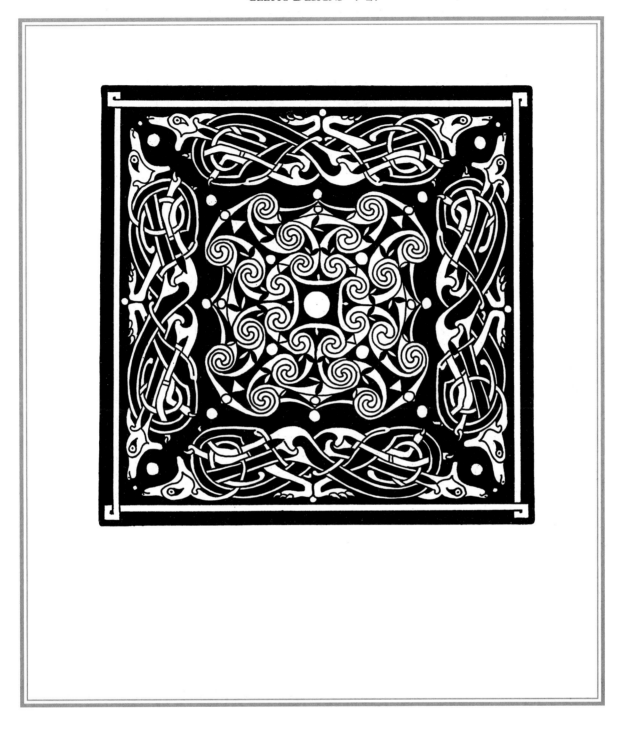

13 Ceramic-tile design employing Celtic beasts with a central spirals pattern.

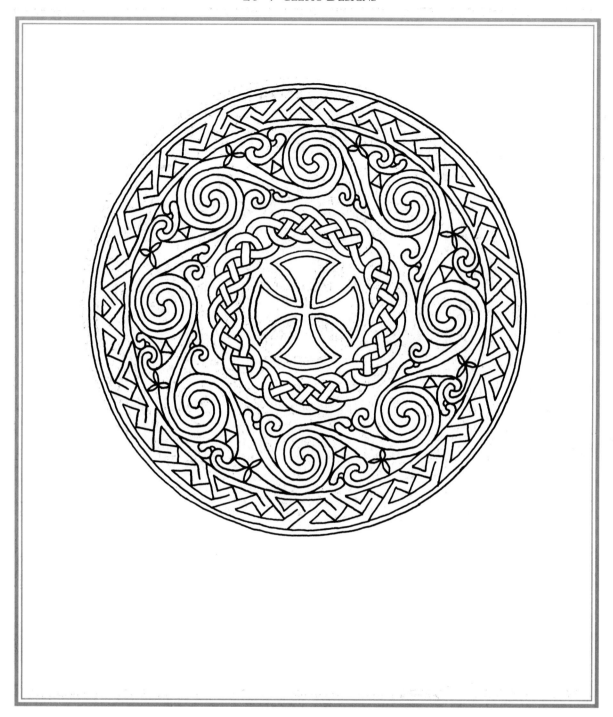

14 Preliminary line drawing for the following design.

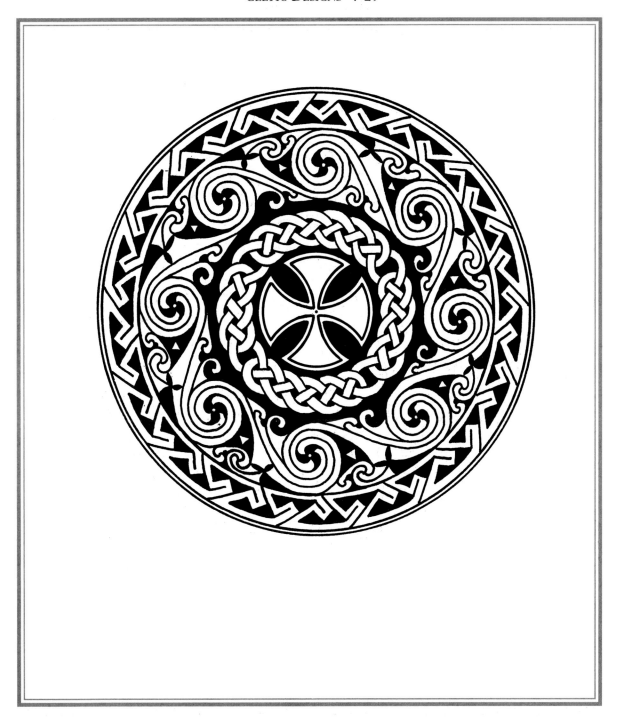

15 This 'Celtic Cross Mandala' was originally an A3-sized colour painting and subsequently was used by The Welsh Gold Centre in Tregaron as a coaster design, printed in gold on leather.

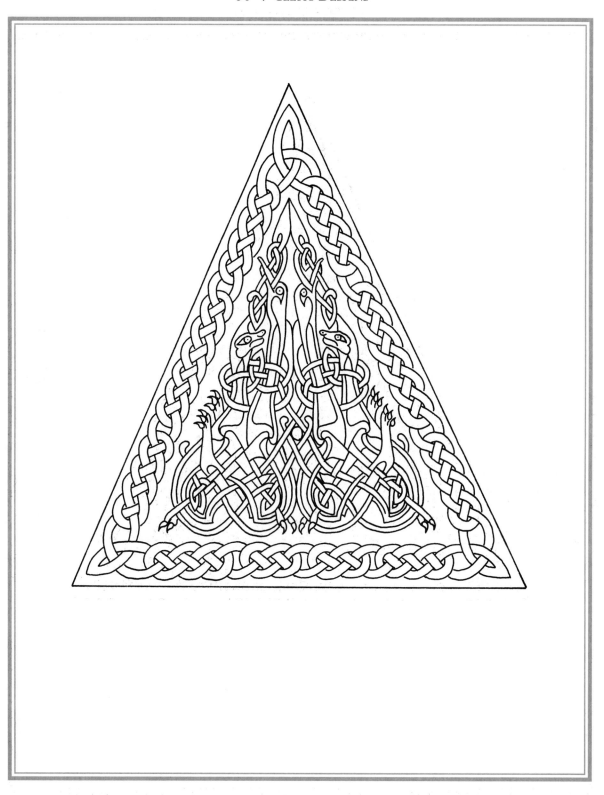

16 Preliminary line drawing for the following design.

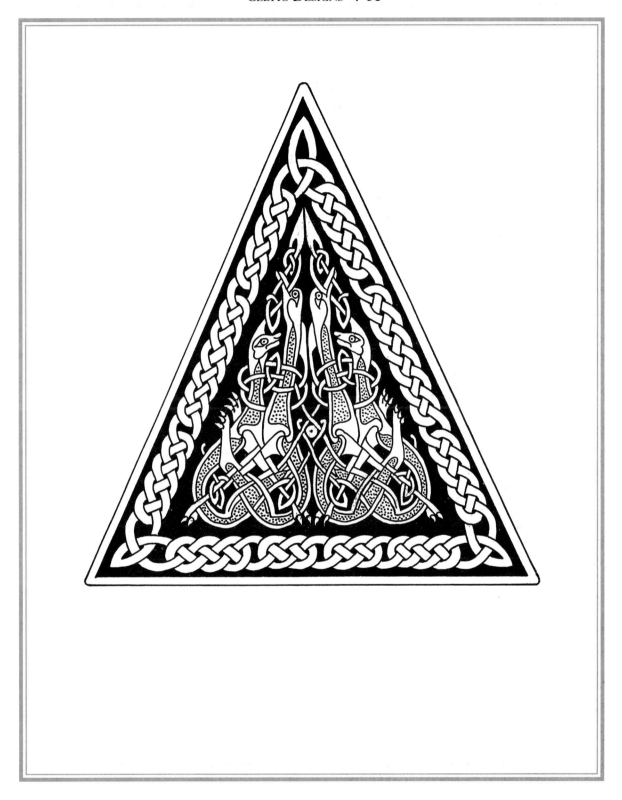

17 'Aspirant Beasties' was originally a colour painting, later modified to this solid form for use in jewellery as a design for ear-rings.

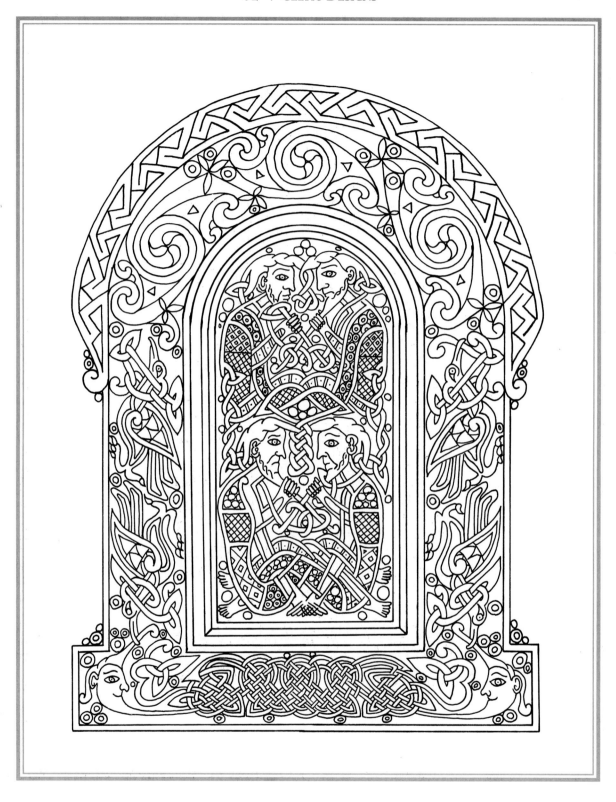

18 The following full magazine-cover design in its preliminary line-drawing format.

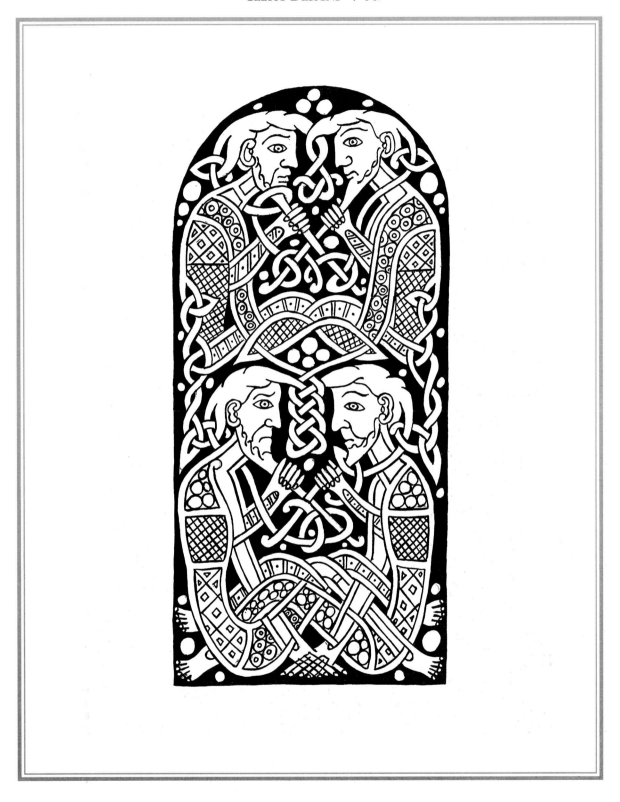

19 Enlarged centre-design of a cover illustration for *Chalice* magazine, Newport, Gwent, Wales (1992).

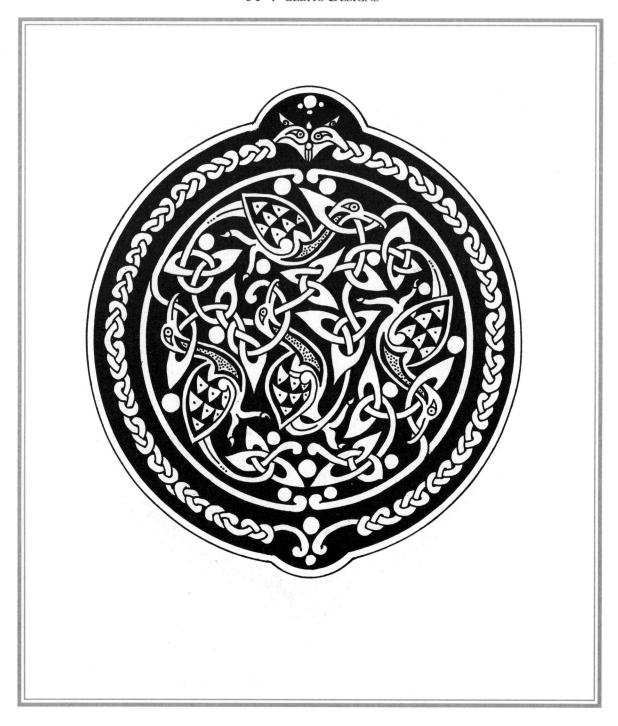

20 'Sun Birds', a colour painting used as a book-cover design for *The Elements of the Celtic Tradition* (Caitlin Matthews, Element, 1988); subsequently produced as colour greetings card.

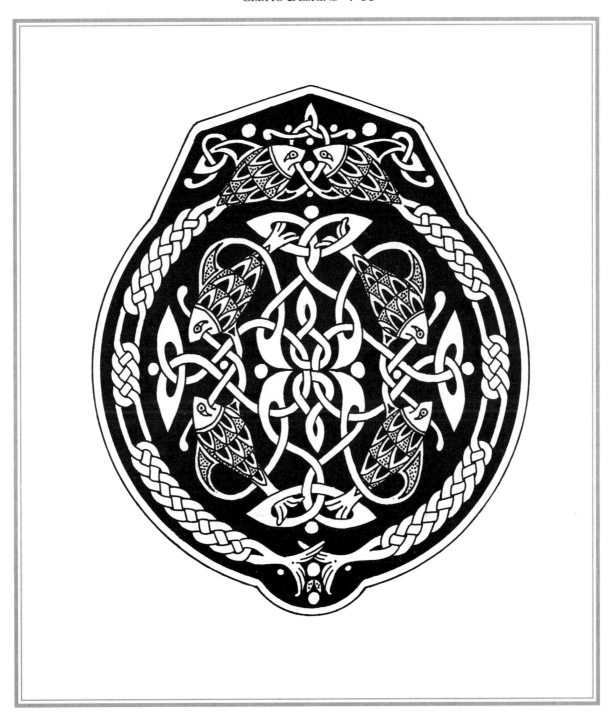

21 'Pisces Celtica', a colour painting first printed as a greetings card, but also used as a cover design for *Keltic Fringe* magazine, Philadelphia, USA (1993).

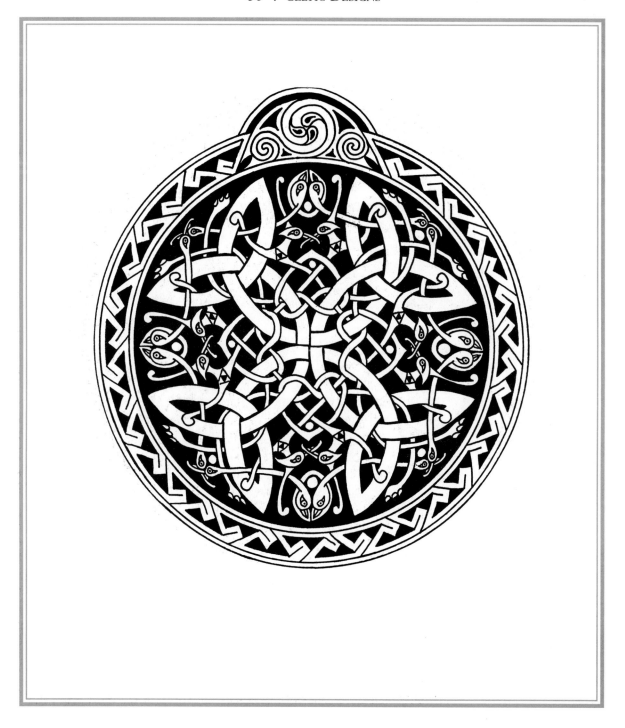

22 The centre roundel of this design, 'Interlace Mandala', was used by The Welsh Gold Centre, Tregaron as a coaster design, printed in gold on leather.

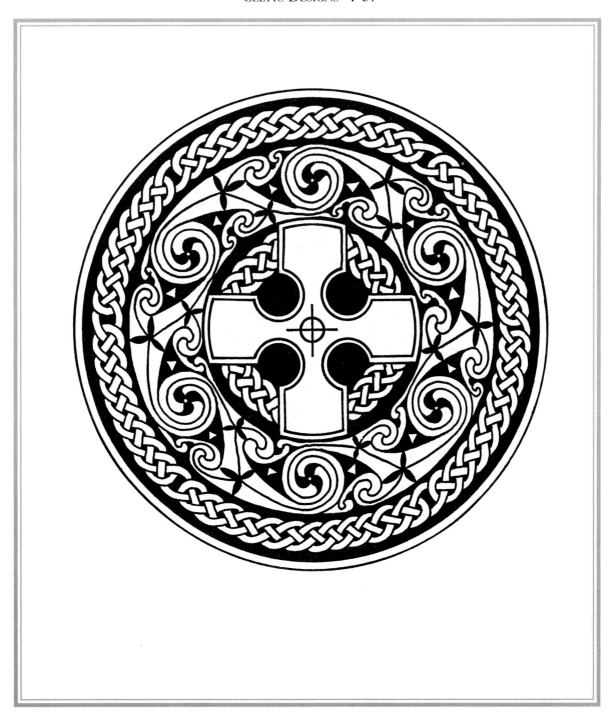

23 'Knotwork Celtic Cross', a colour painting, printed as a greetings card, and later used on large pyrography platters.

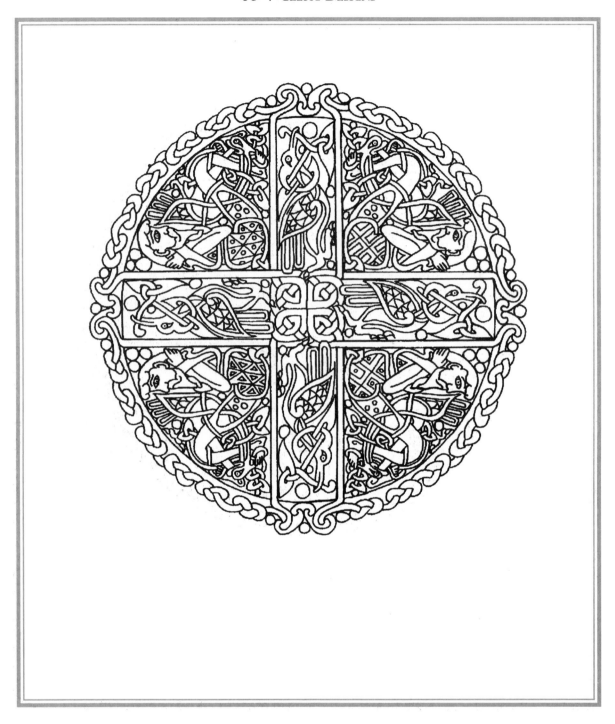

24 Preliminary line drawing for the following design.

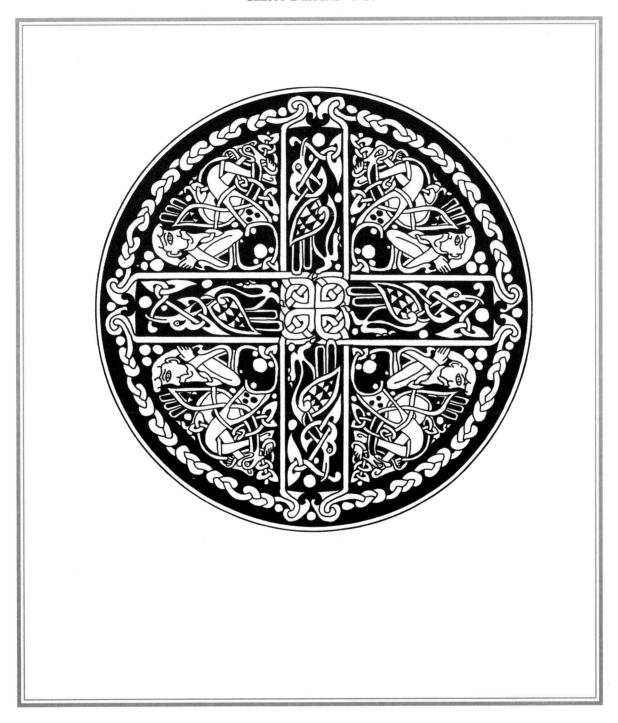

25 'The Meditators', the basis for a colour painting, printed as a greetings card.

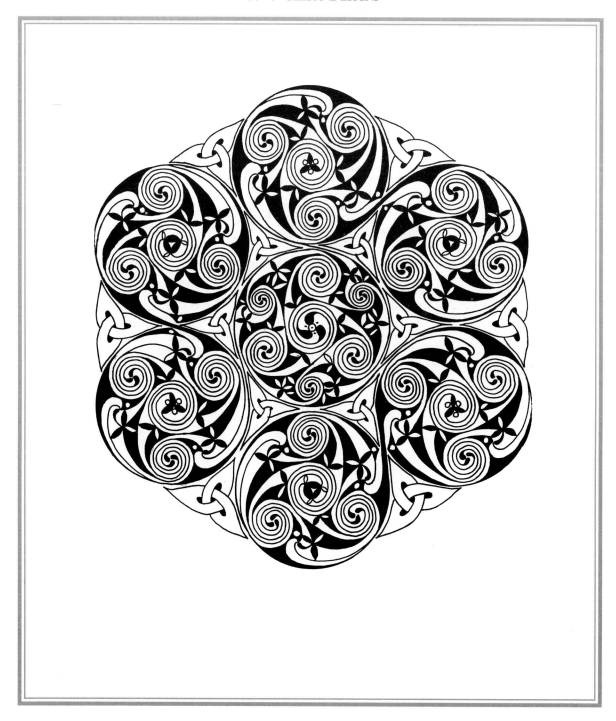

26 Design used for a window transparency, printed in gold on self-clinging transparent vinyl.

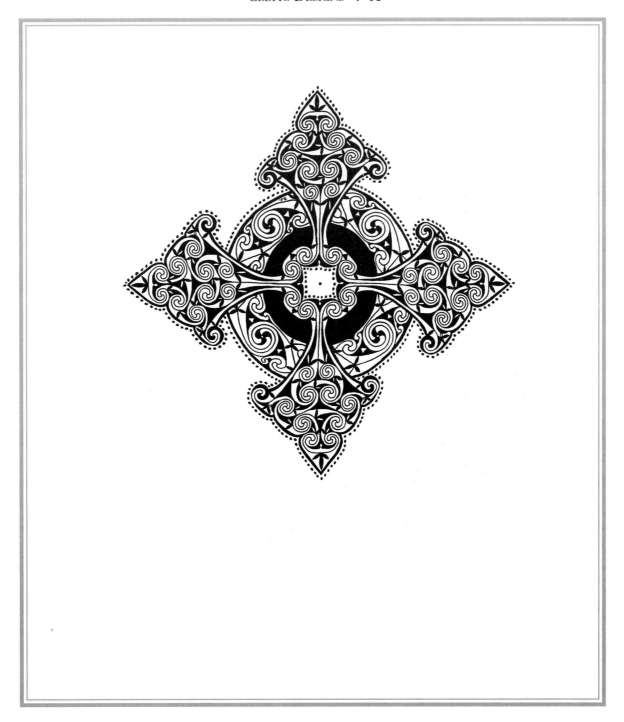

27 'Radiant Celtic Cross', a colour painting printed as a greetings card, but in this black and white version suitable for silver or gold jewellery.

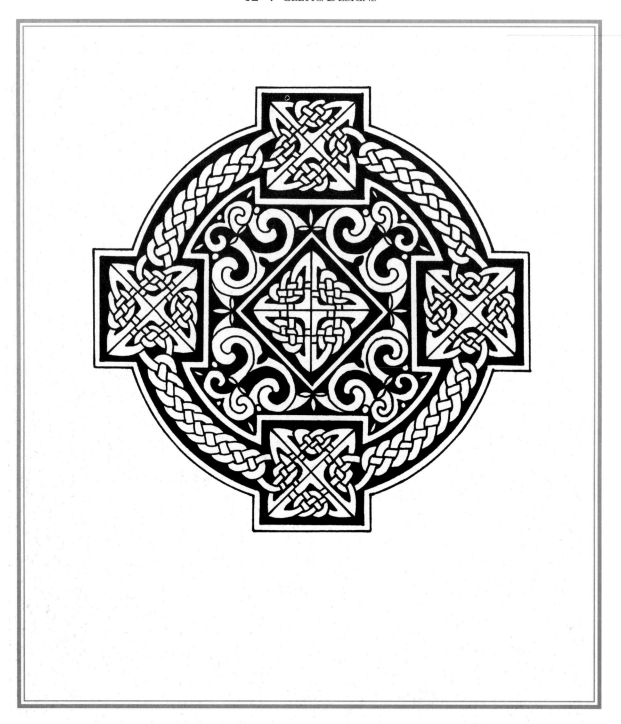

28 Detail of the central knotwork roundel of the following design.

29 Cover design for *Celtic Connections* magazine (1992).

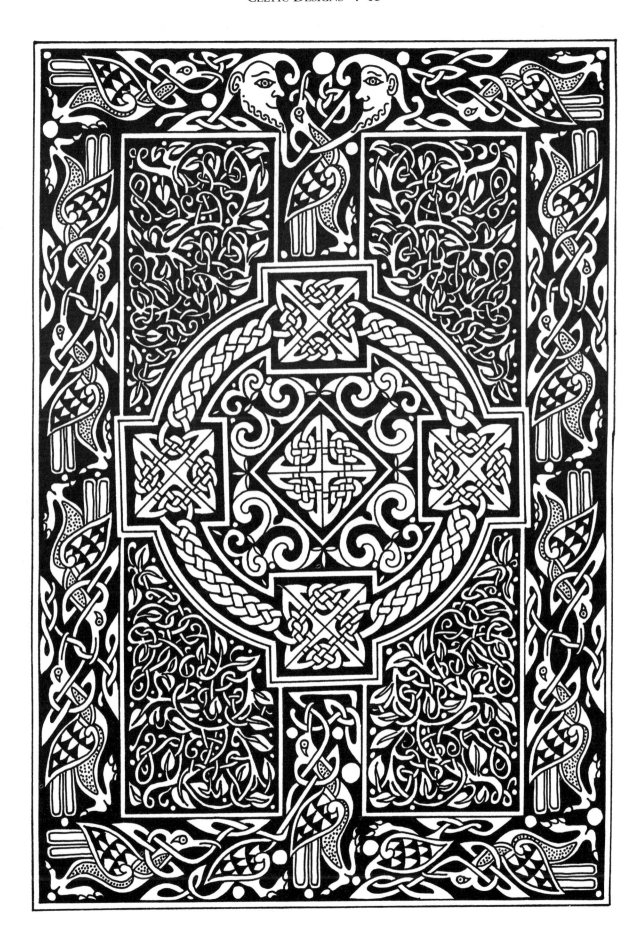

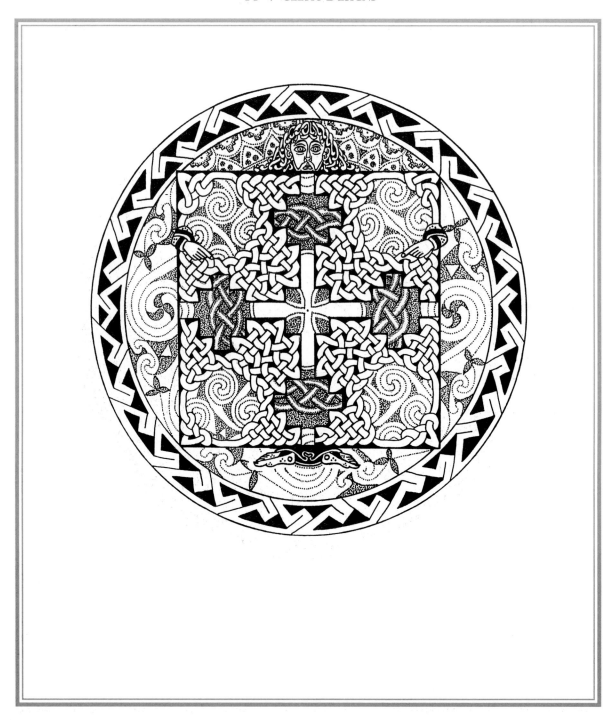

30 Magazine design for an article on Celtic saints in *Celtic Connections* magazine (1994).

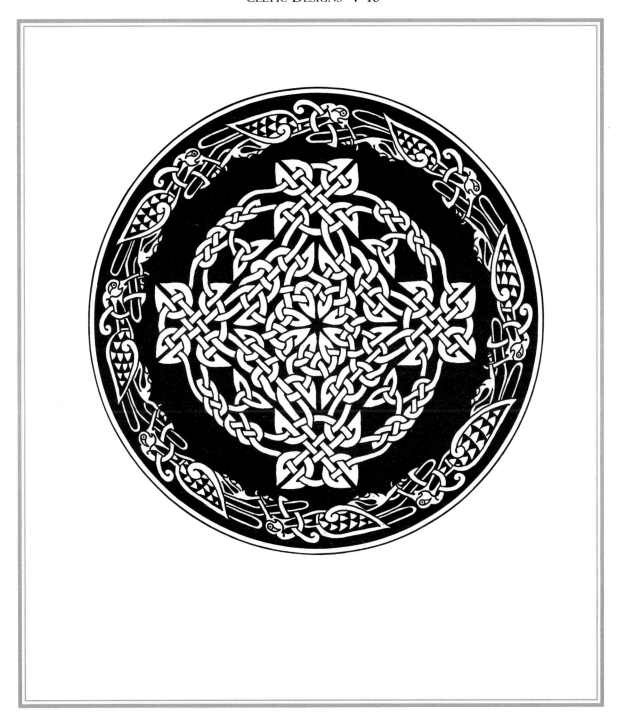

31 'Bexington Birds' was a birds and knotwork design used on hand-thrown ceramic plates, and subsequently used for pyrography (1993).

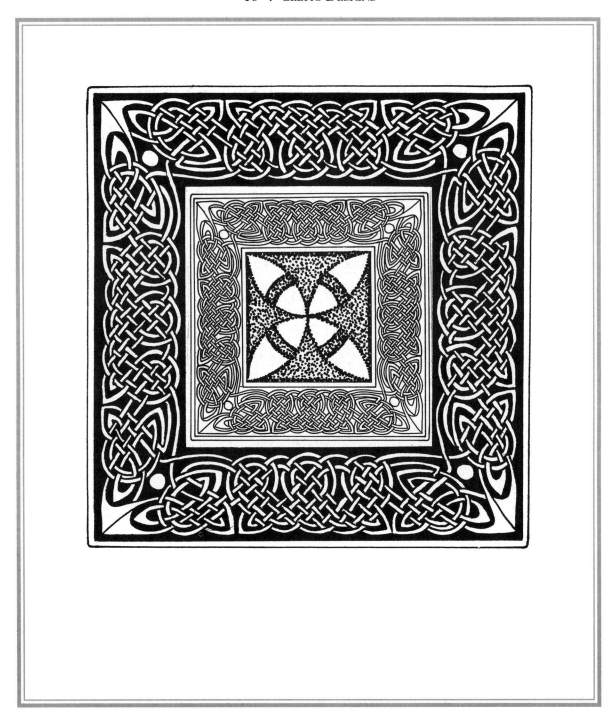

32 Ceramic-tile design with elaborate knotwork border.

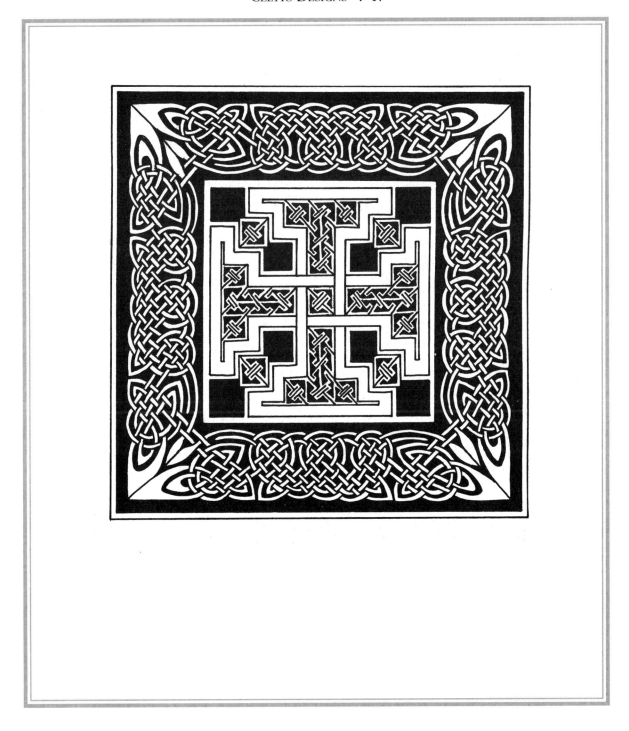

33 A further version of the ceramic-tile design with elaborate knotwork border and a key-pattern centre.

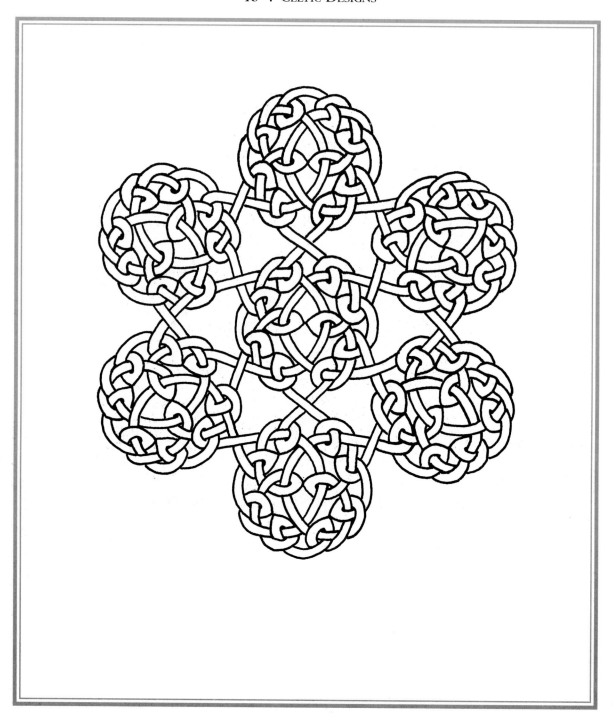

34 Preliminary line drawing for the following design.

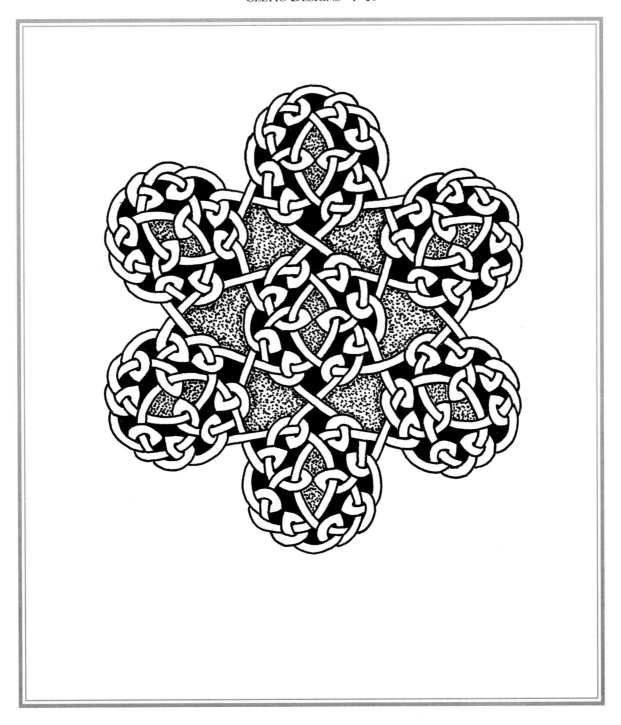

35 Knotwork 'Celtic Snowflake' design, created for use as a repeated pattern in fabric-printing (1996).

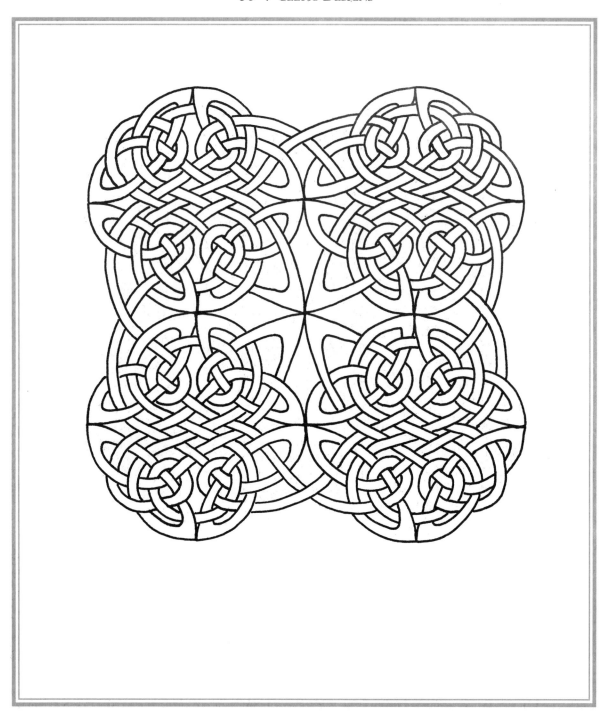

36 Preliminary line drawing for the following design.

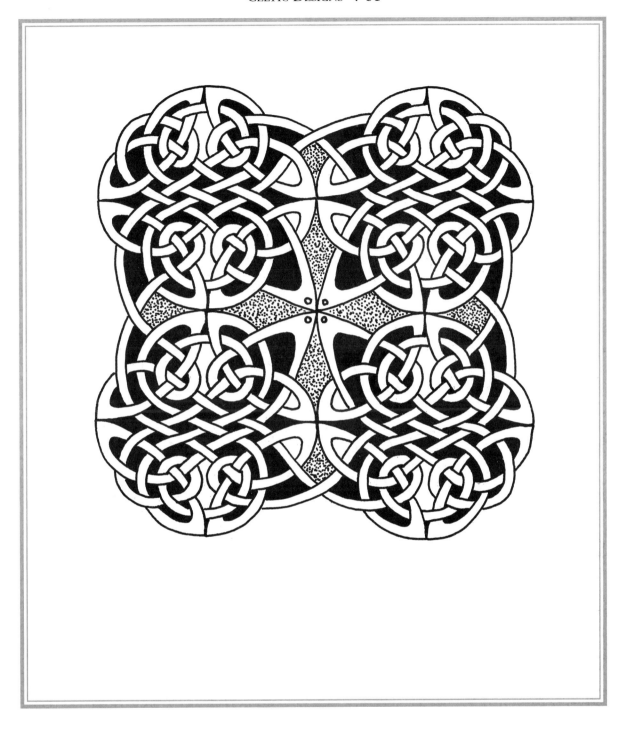

37 'Four-knots', a design for use as a repeated pattern in fabric-printing (1996).

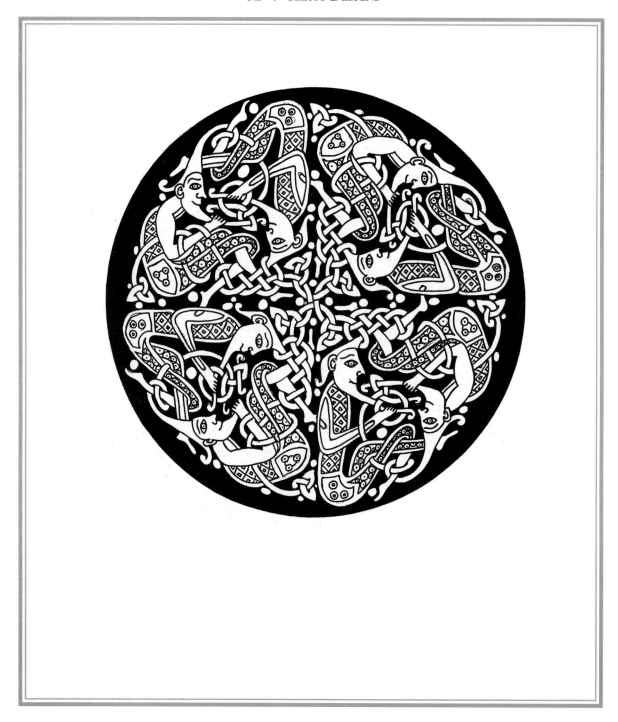

38 Centre panel of a cover design for *Celtic Connections* magazine, (1993).

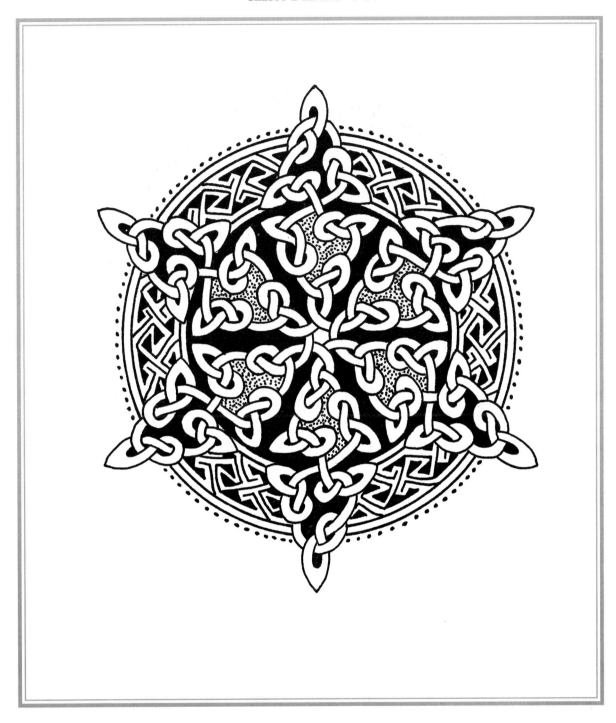

39 'Knotwork Star', a monochrome design for printing on fabrics, T-shirts, etc.

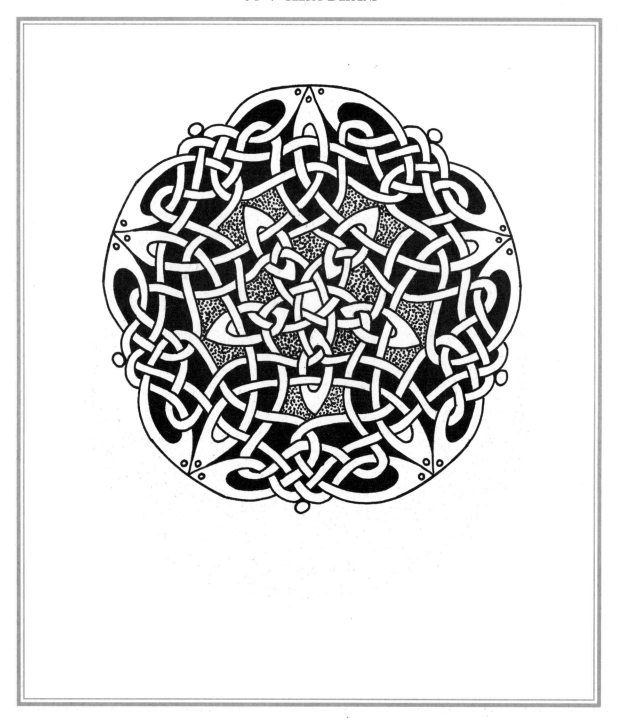

40 'Five-pointed Star', monochrome design for printing on fabrics, T-shirts, etc.

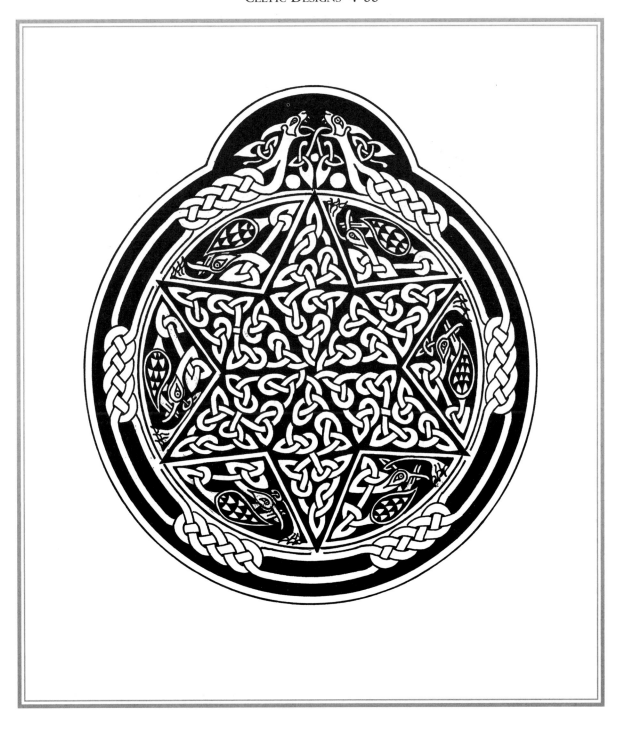

41 'Celtic Star', a colour painting, printed as a greetings card and also a colour poster.

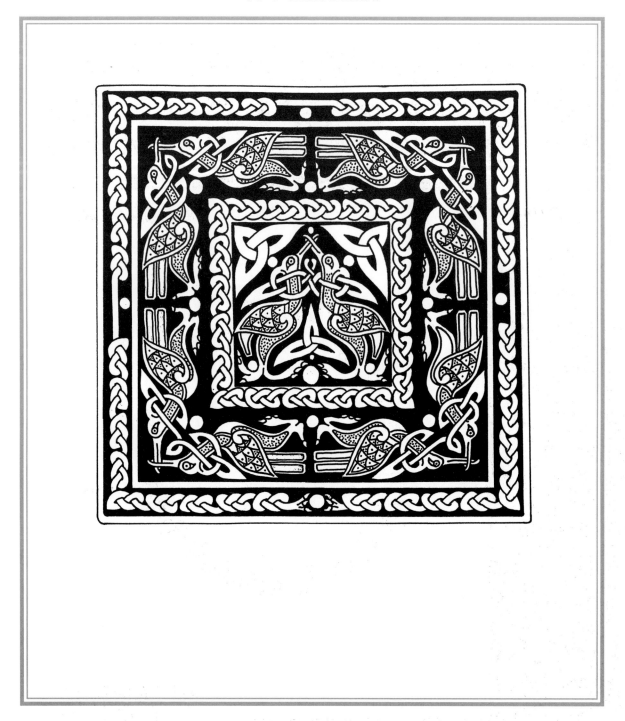

42 'Birds of Friendship', a colour painting originally created as a ceramic-tile design (1984), then printed as a colour greetings card.

43 Monochrome design for a Celtic wedding invitation card, commissioned in 1987. The circular birds design within is for use on pottery, and also on round, lidded wooden boxes, using pyrographic techniques.

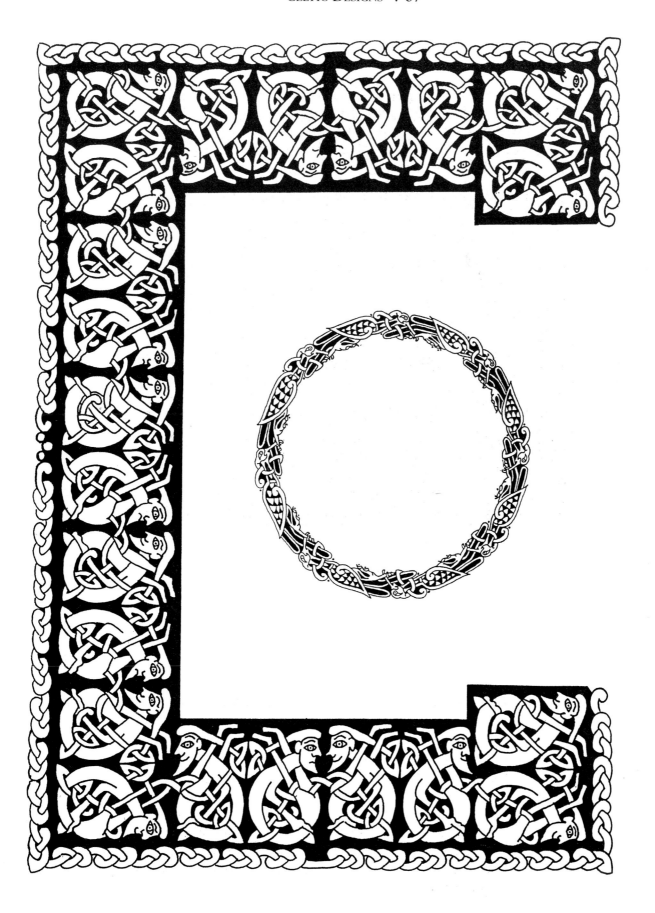

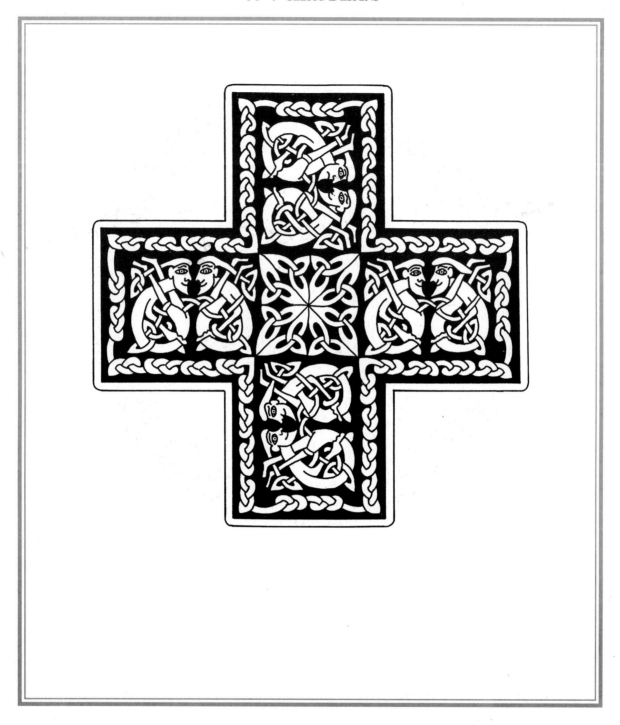

44 'Celtic Monks' cross, designed for use as an elaborate pewter pendant.

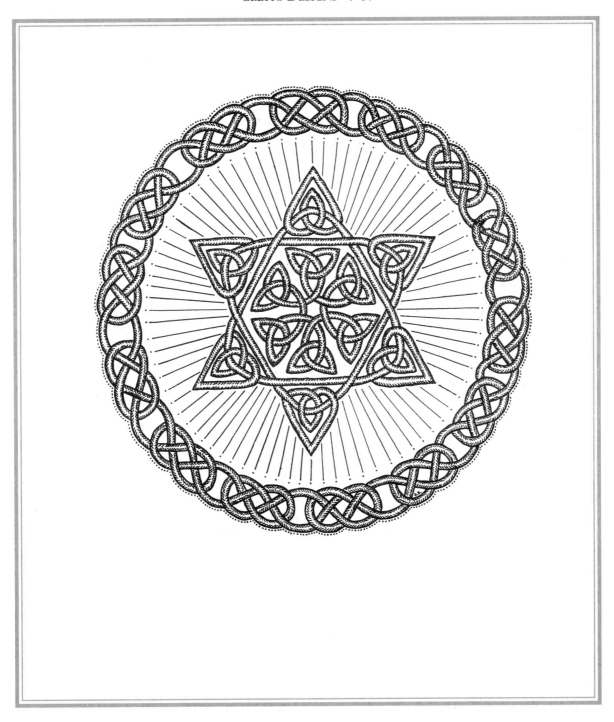

45 'Radiant Star', a monochrome design used as a Christmas card (1980).

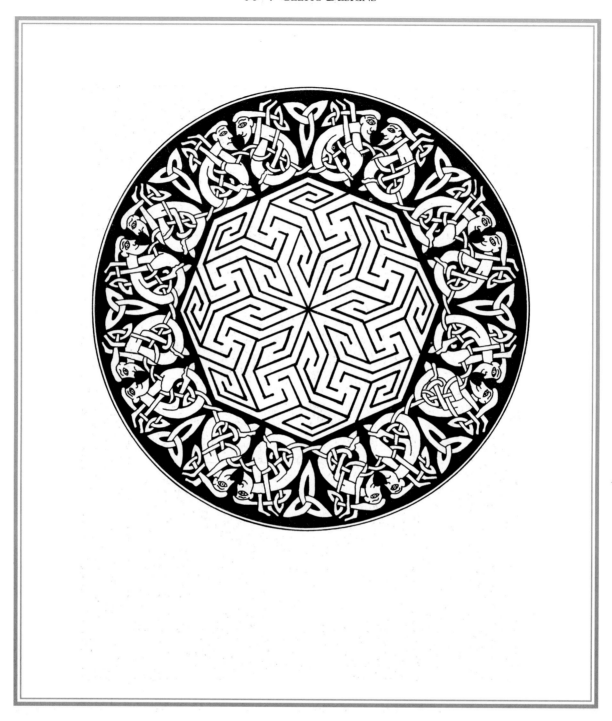

46 Monochrome design for large poster advertising circle-dancing workshops (1989).

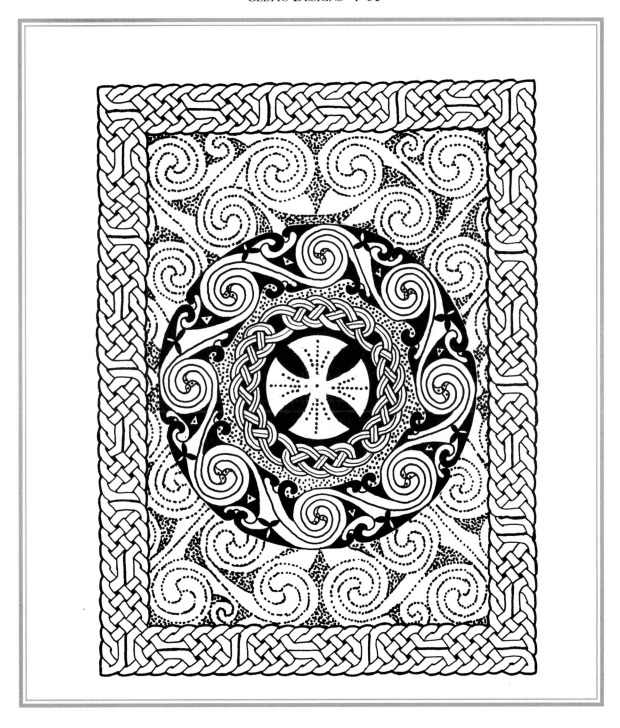

47 Magazine cover design for *Keltria* magazine, Minneapolis, USA.

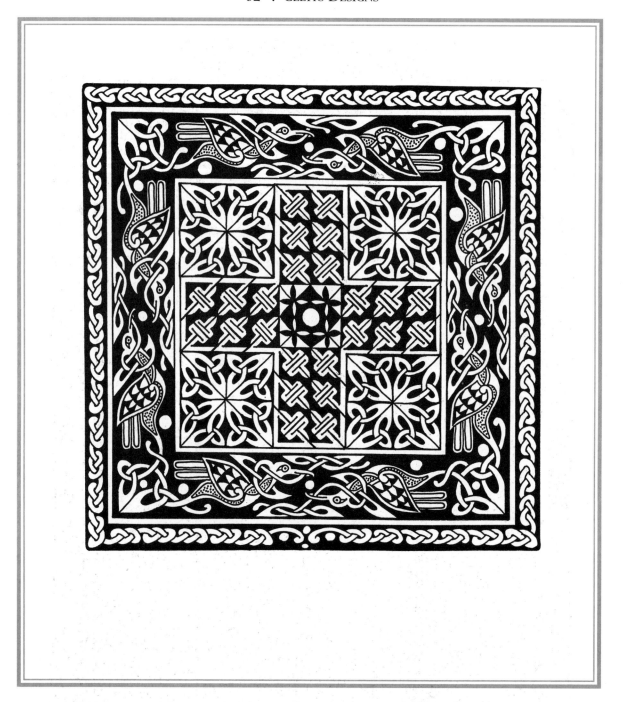

48 Design for a ceramic tile, incorporating birds, knotwork and key patterns.

49 Cover design for *Ore* poetry journal (1986). This design is meant to be stereographic, i.e. if you hold the book at arm's length and blur your vision slightly, the centre panel will slowly appear to take on a strong three-dimensional effect, giving the illusion of appearing behind the page itself!

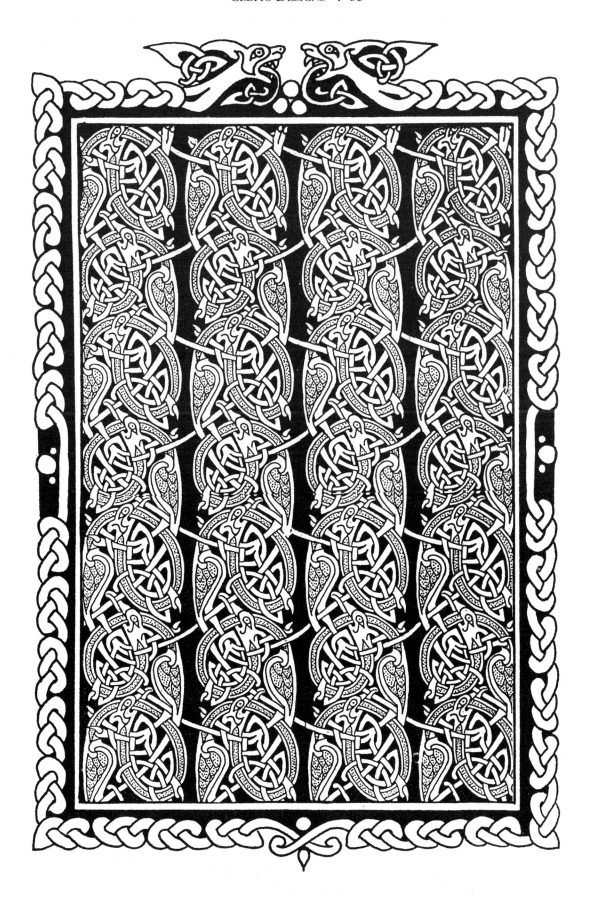

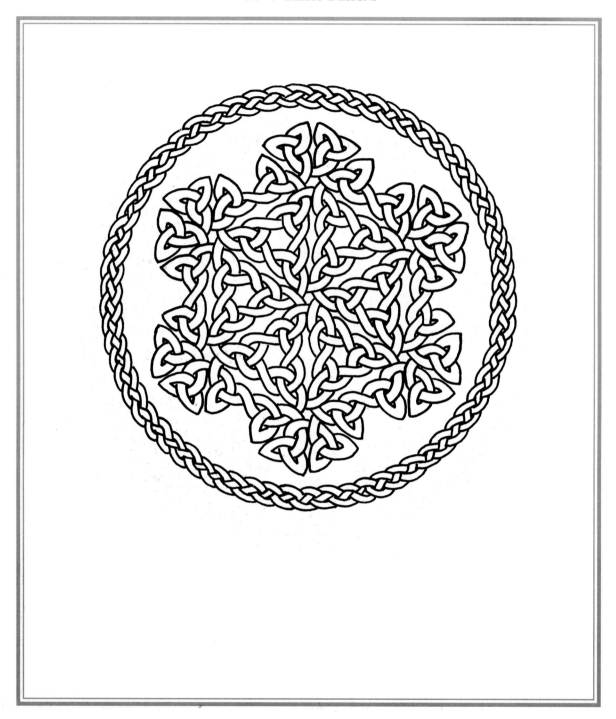

50 Preliminary line drawing for the following design. An
enlargement of this line drawing was used to transfer the design
onto an oak coffee-table top, on which it was subsequently carved.

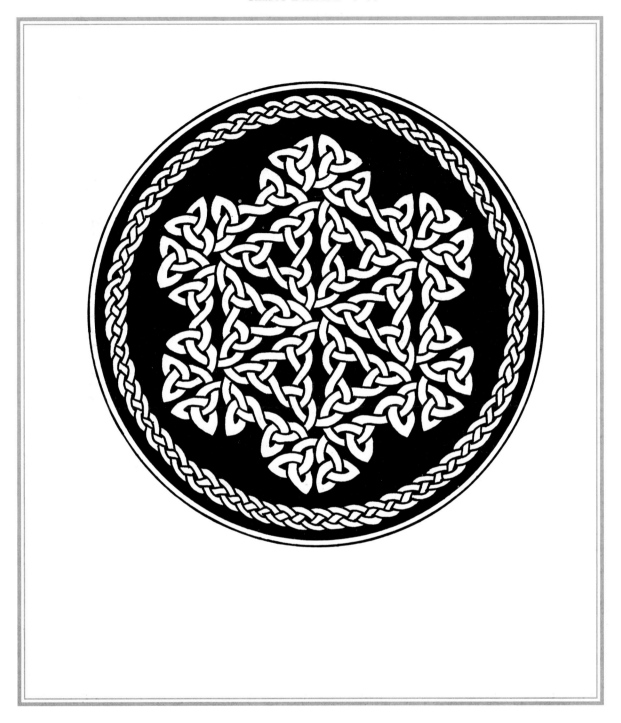

51 Cover design (1978) for the book *Celtic Art – The Carved Stones of Western Scotland* (see Introduction). The original is in colour, and was subsequently used for a calendar cover by M.I.S. Publications, California, USA.

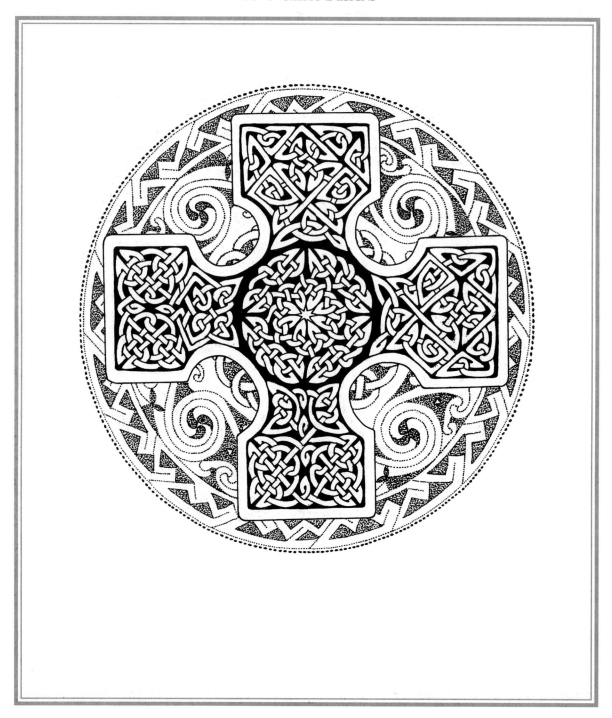

52 'Canna Cross' – version I – used as a monochrome cover design for *Celtic Connections* magazine (1994).

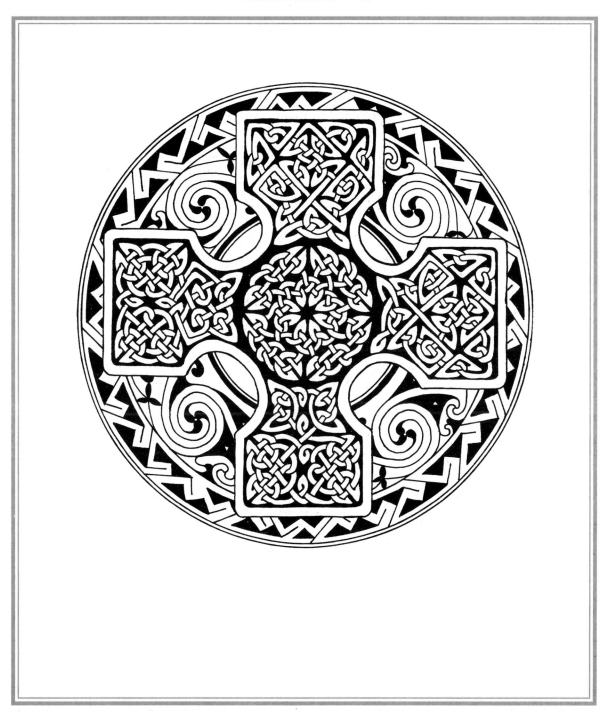

53 'Canna Cross' – version 2 – the original is a colour painting.

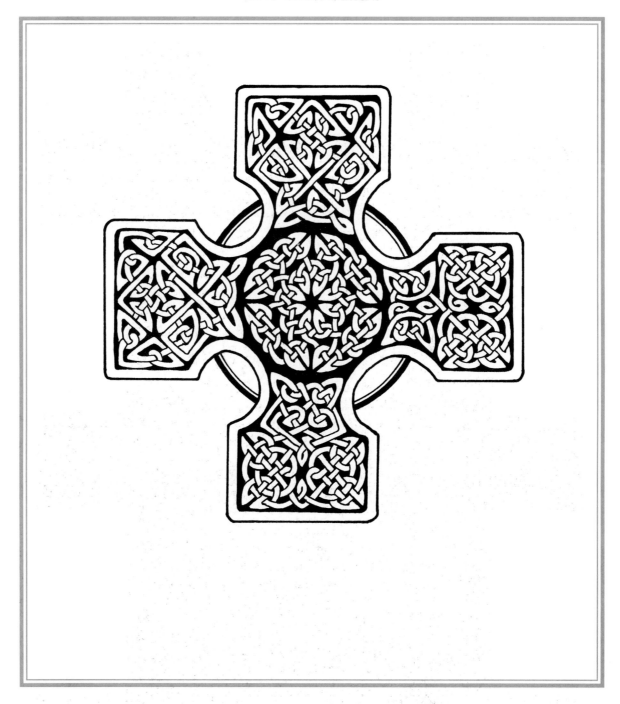

54 'Canna Cross' – version 3 – designed without the circle for use in creating a very elaborate and unique silver or gold pendant.

55 'Celtic Composite', a combination of two different designs, repeated to form an elaborate panel and used in *Celtic Connections* magazine.

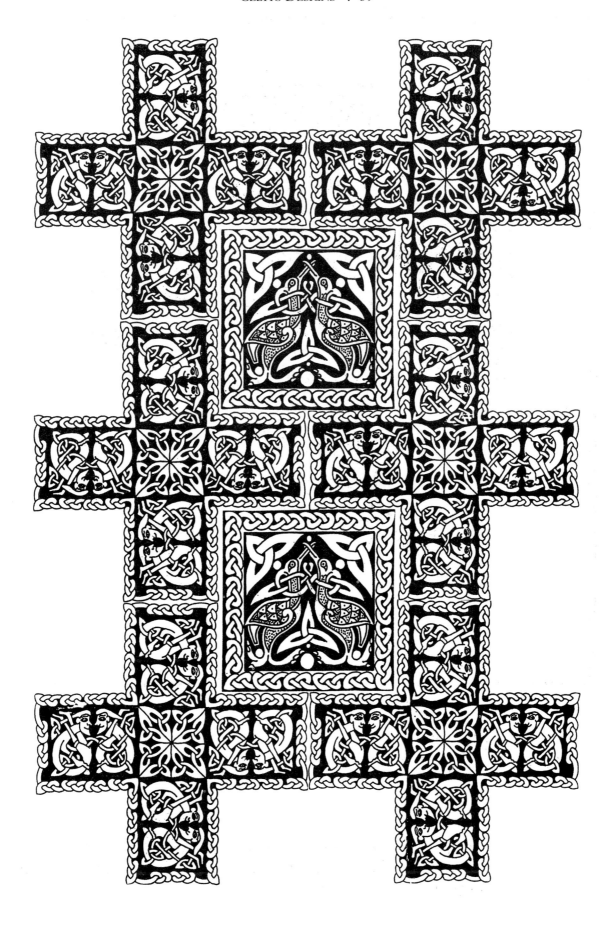

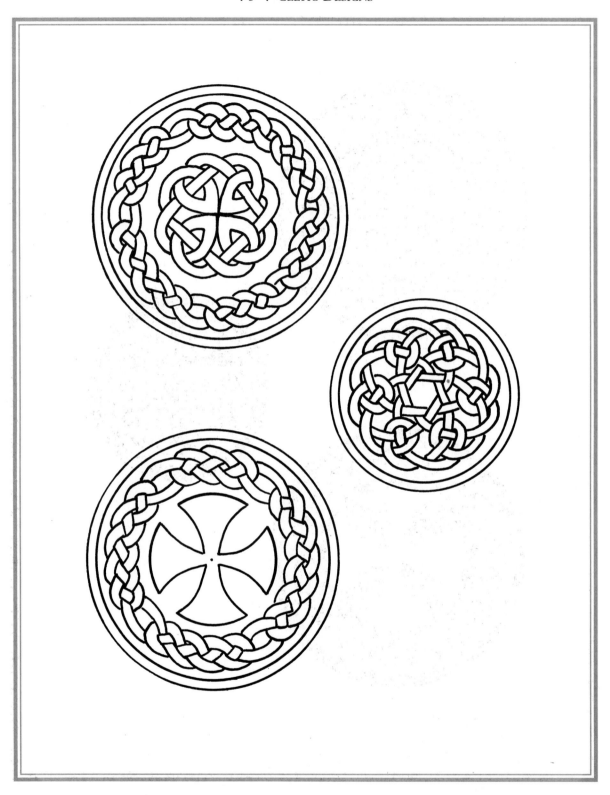

56 Preliminary line drawings for the following designs.

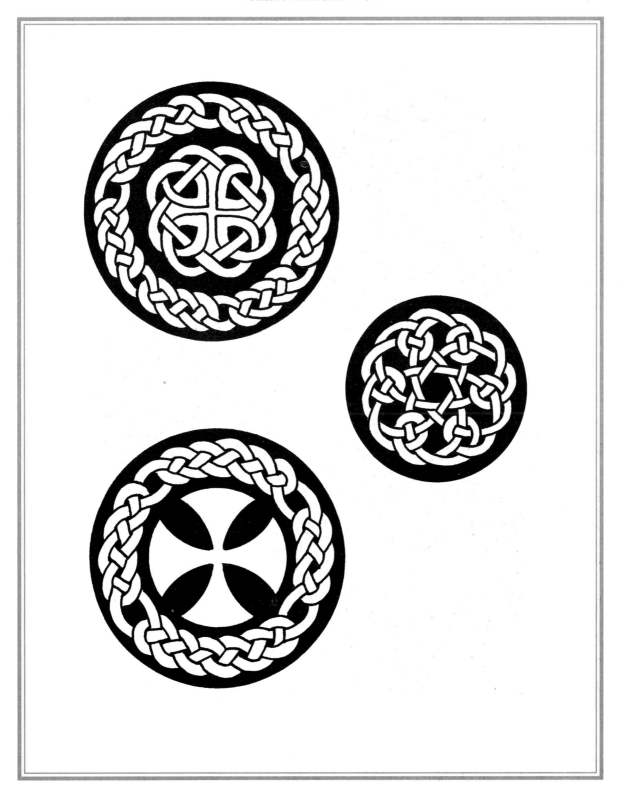

57 Small knotwork designs used for pyrography on round, lidded wooden boxes turned from limewood; also used by the stencil method (see Introduction) on enamelwork.

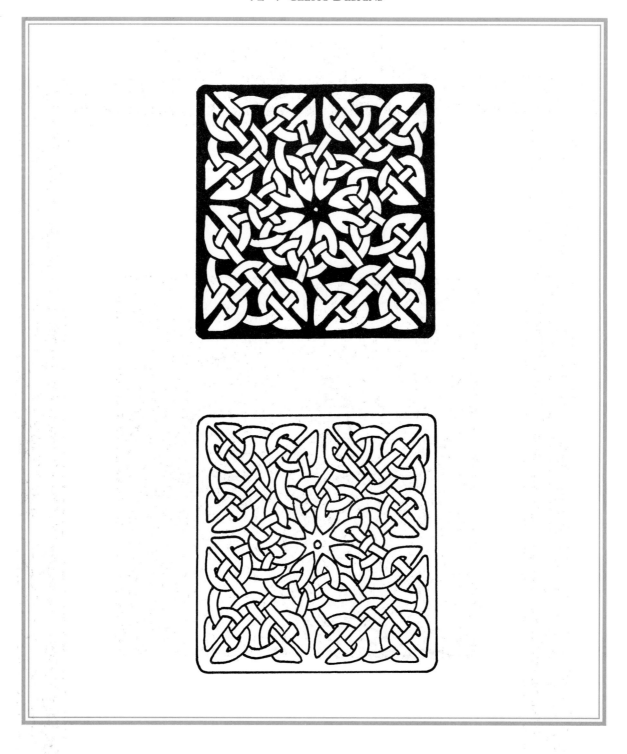

58 Ceramic-tile design, using a 'squared' version of the centre of the 'Canna Cross' design shown earlier; also the preliminary line drawing.

59 Monochrome border for a poster; the square design within is for a ceramic tile.

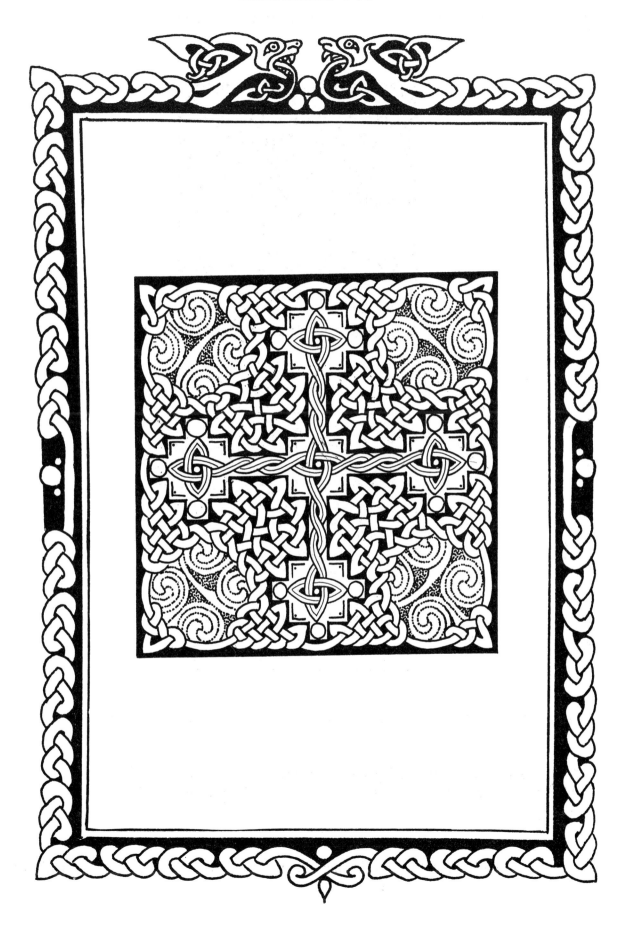

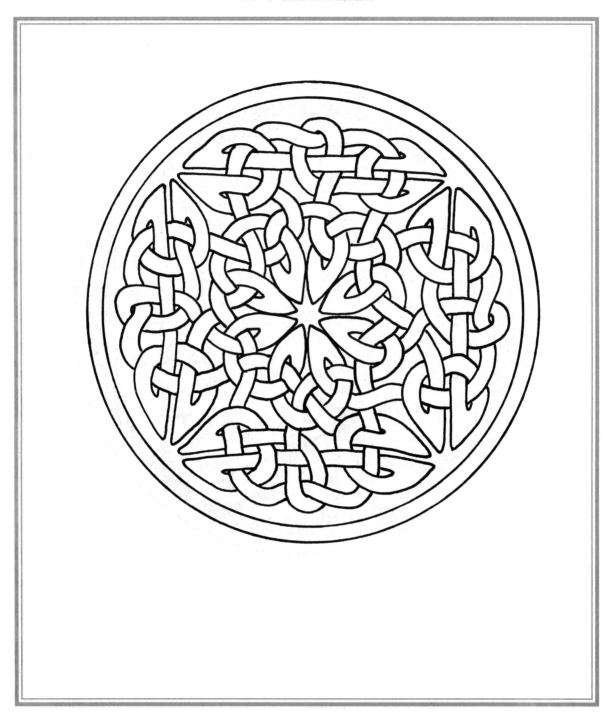

60 Preliminary line drawing for the following design also used to transfer the design onto a seasoned and polished oak plaque, prior to carving.

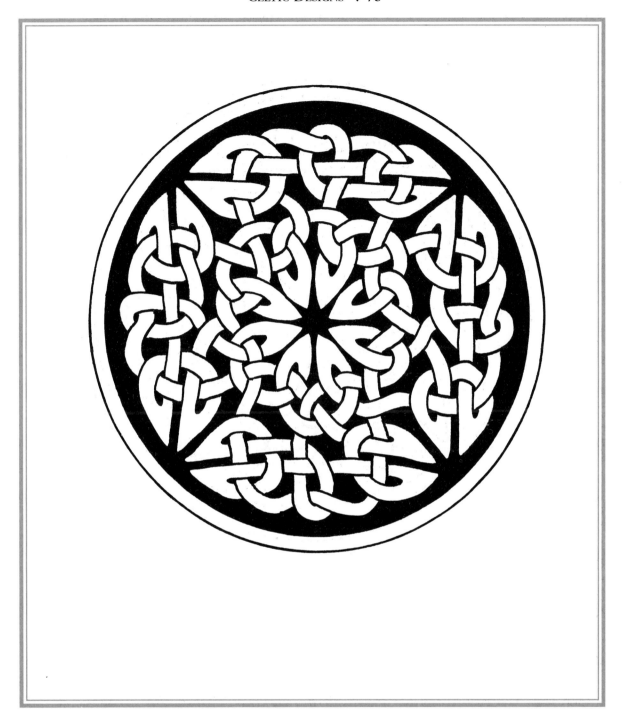

61 Design for a carved ceramic clock-face and a further treatment of the 'Canna Cross' design. A hole was cut into the centre of the clay roundel to accommodate the clock movement and small polished brass rivets set into the outer ring for the position of the hours.

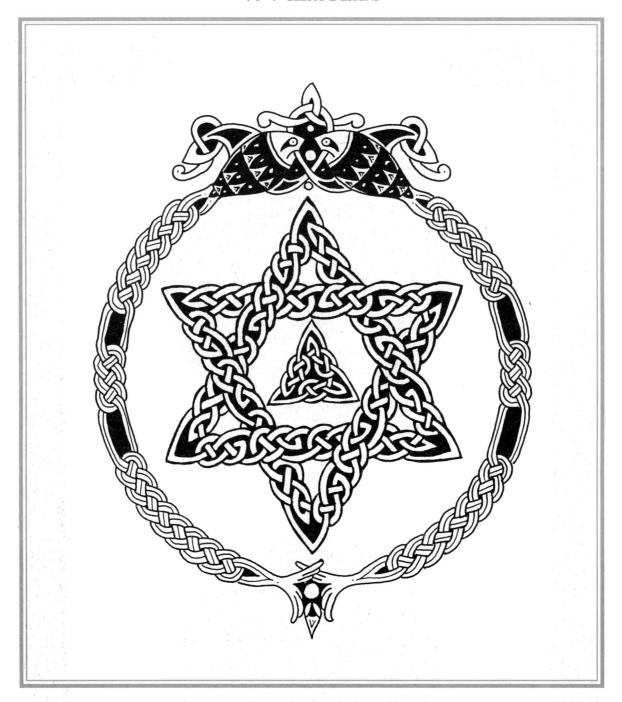

62 Commission (1990) for a hanging sign outside a specialist Celtic crafts shop. The design was carried out using coloured enamel paints on both sides of a large, carefully shaped piece of heavy plywood with a beaded surround, and then given two coats of clear varnish. The finished sign incorporated the shop's name, 'Serendipity'.

63 Elaborate poster border, which is a variation and extension of a knotwork motif from the *Book of Lindisfarne*. The circular design within it was used in pyrography on round, lidded wooden boxes, and also shallow wooden bowls.

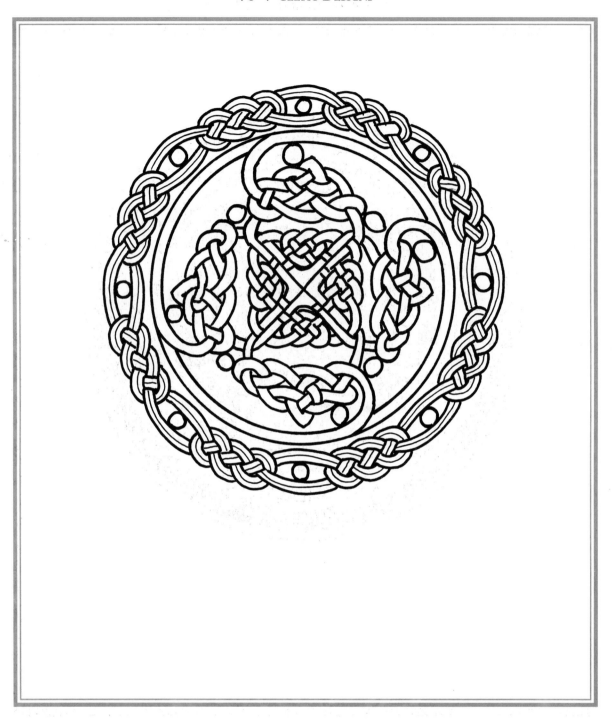

64 Preliminary line drawing for the following design.

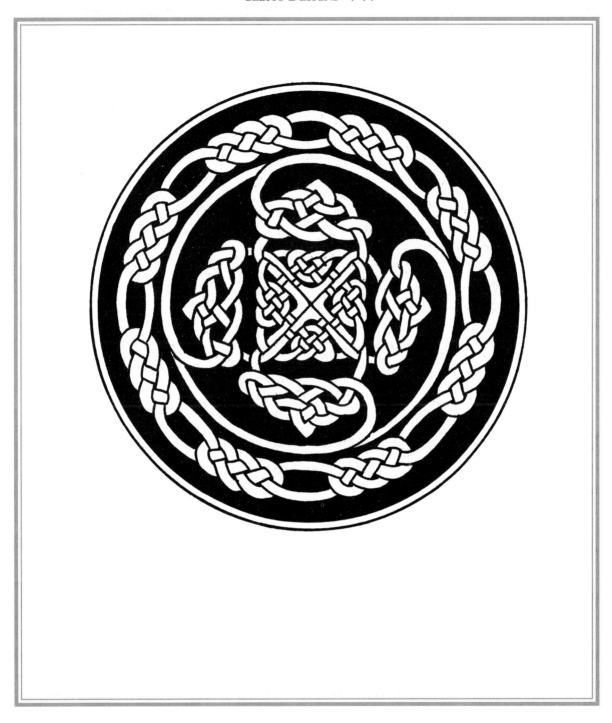

65 Monochrome version of a small colour painting which I have used on pottery plates and smaller pyrography wooden platters.

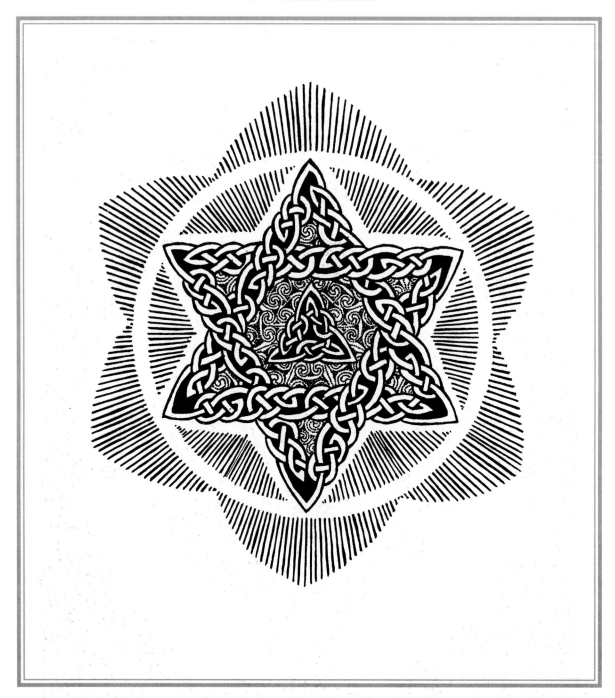

66 'Sun Star', a monochrome design for printing on T-shirts.

67 Preliminary line drawing used as a basis for the cover of a 1977 calendar with monochrome illustrations. This was one of my very early larger designs, noticeable by the fact that I had not yet learned the discipline of 'mitring' the knotwork corners and junctions, hence several lines join at one point throughout the design. To the trained eye, this gives a very rudimentary appearance, and is a reminder to me of how my artwork has progressed over the years!

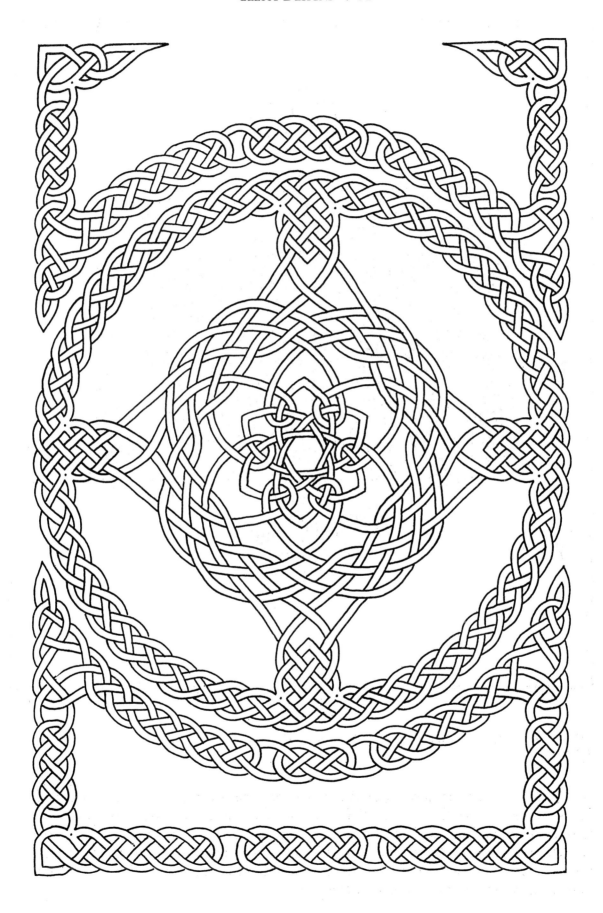

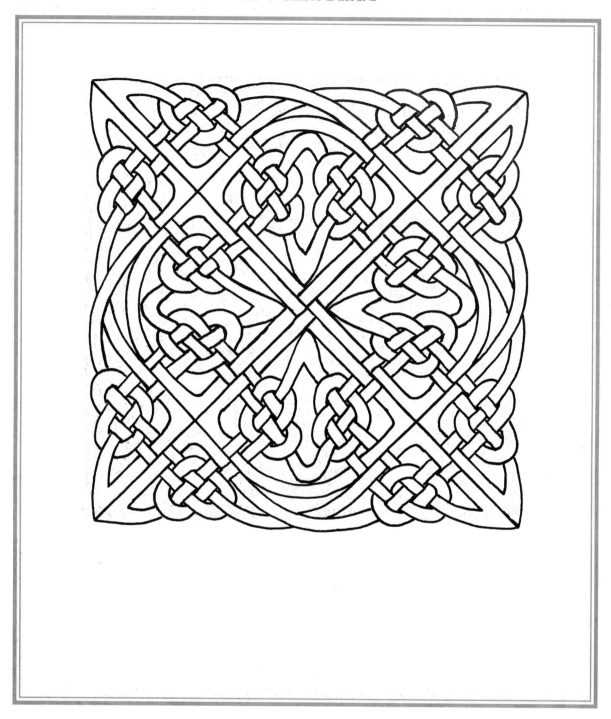

68 Preliminary line drawing for the following design.

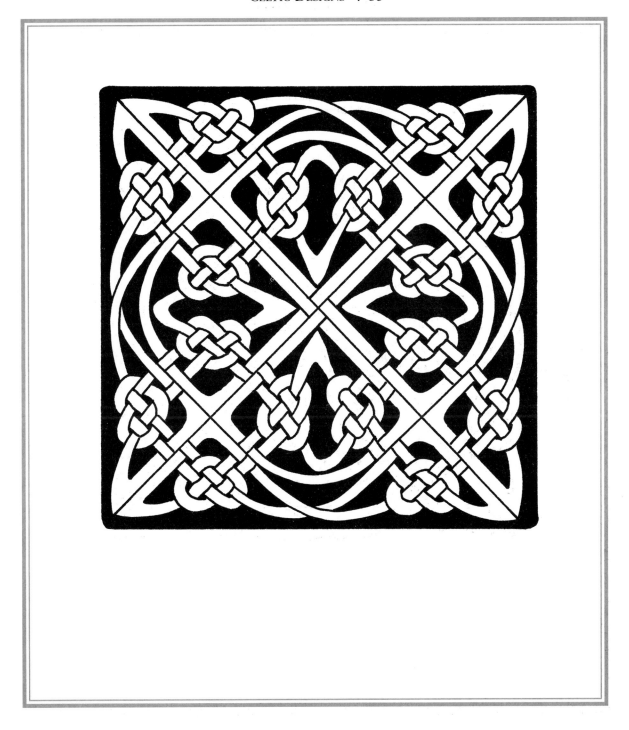

69 Design for a ceramic tile (1996). The design is symmetrical, and so is useful for an overall wall tile pattern where any edge can be laid against another.

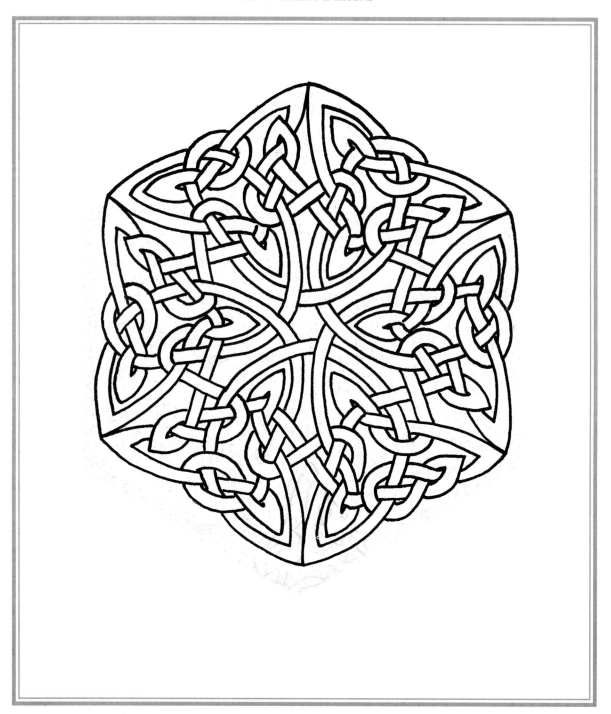

70 Preliminary line drawing for the following design.

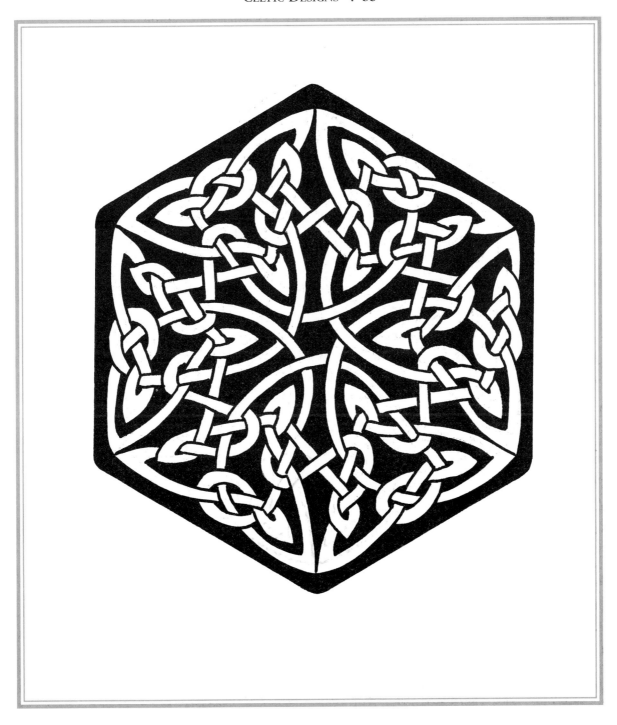

71 Design (1996) for a more ambitious, hexagonal ceramic tile.
Tiled surfaces using a repeat pattern of many adjoining
hexagons can appear very attractive (and also rather Oriental).

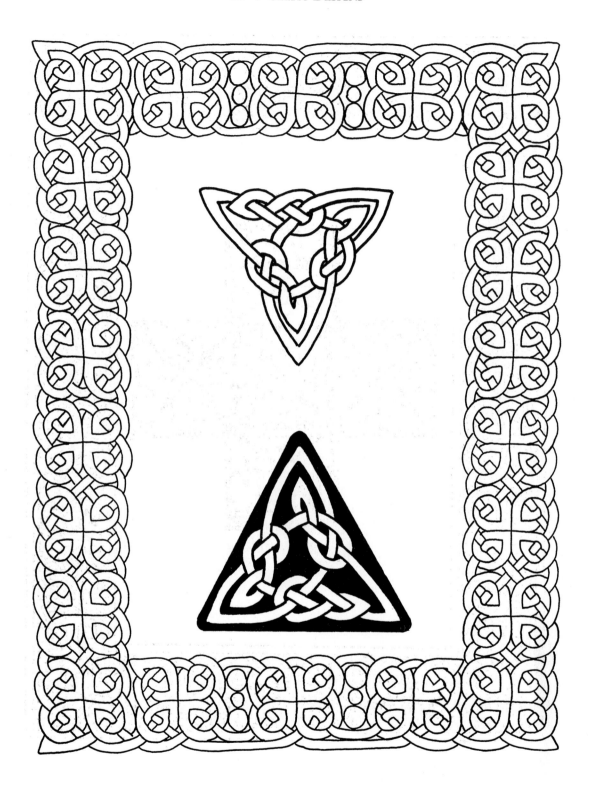

72 Knotwork border in its preliminary line-drawing stage. Several different completed full-PPcolour versions can be seen in the book *Celtic Connections* (Blandford, 1996). It is interesting how colour can almost totally transform a design. The small triangular design in both solid and line-drawing formats was used on copper enamel, employing the stencil method.

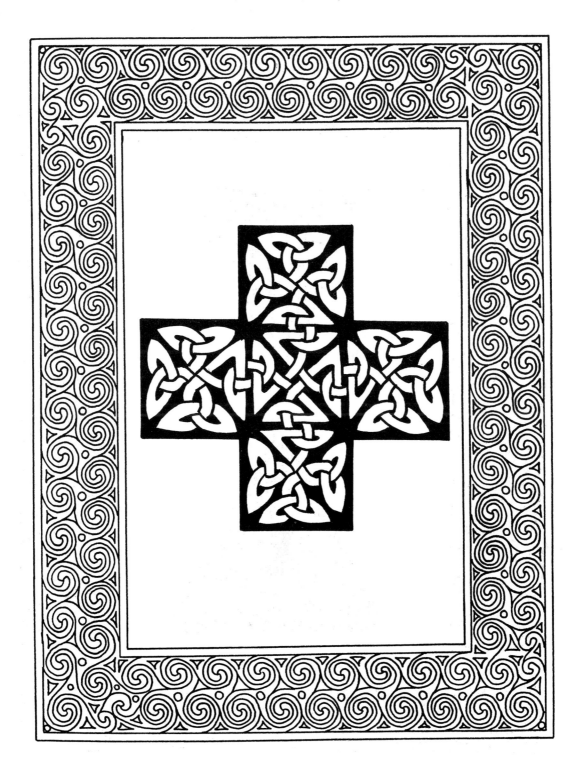

73 Spirals border in its preliminary line-drawing stage. As with the previous design, several different, completed full-colour versions can be seen in the book mentioned. The central cross design is an adaptation of a small knotwork motif in the *Book of Kells*, which I have used on ceramics as well as for pyrography.

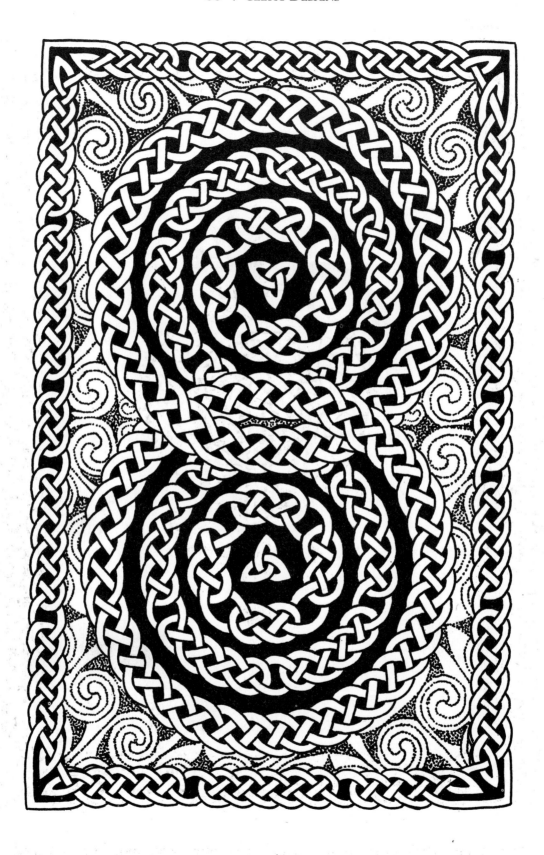

74 Commissioned design carried out by pyrography on a large rectangular sycamore-wood plaque (1985).

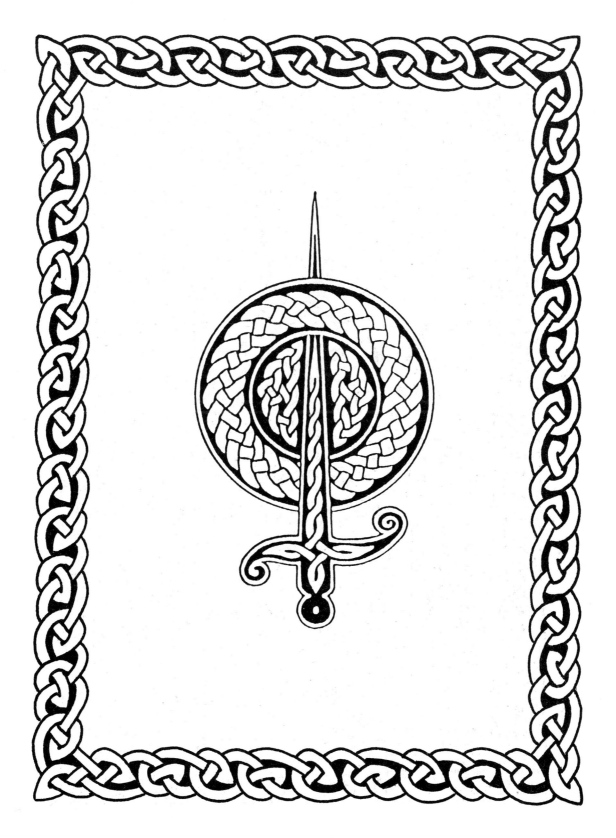

75 Border design for a poster though the central sword motif was designed originally as a logo for a greetings-card company (Excalibur Designs) whose work was mainly Arthurian-based.

76 Border for letter-paper, an elaboration and extension of a knotwork panel from the *Book of Durrow;* also a triangular design which is suitable for use in jewellery on ear-rings.

77 Complex knotwork border which is a variation and extension of a small panel which occurs in the *Book of Lindisfarne*. I have used this border on a variety of crafts and the simple knotwork motif within is suitable for translating into jewellery or enamelwork. The solid version of the triangular, partly filled line-drawing is shown in the previous design.

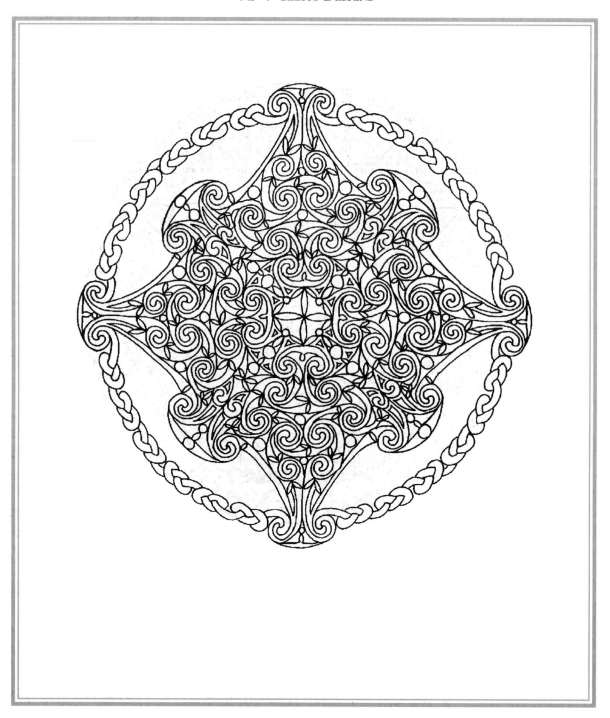

78 Preliminary line drawing for the following design.

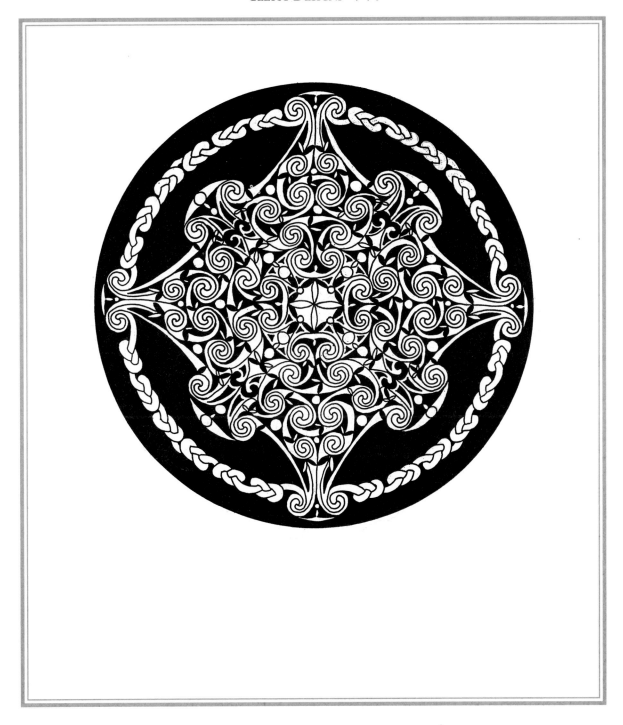

79 'Spirals Mandala' is a black and white version of a colour painting and suitable for use on large ceramic plates or, using pyrography, on good-sized wooden platters or wide, shallow bowls.

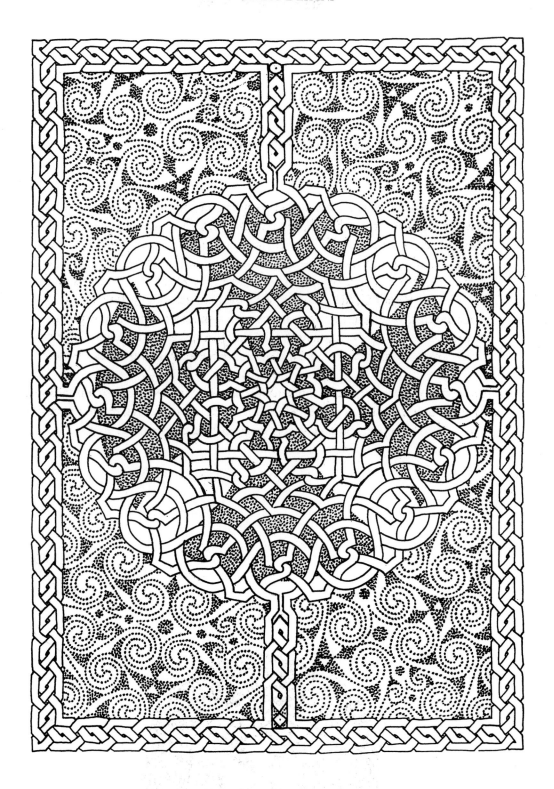

80 'East Meets West', a large, exploratory monochrome design employing an equi-armed Celtic cross and spirals, together with knotwork based on thirteenth-century Islamic geometric principles. The basis of early Islamic knotwork is almost identical to that of Celtic, though the finished line is always given a more angular appearance.

ACKNOWLEDGEMENTS

Special thanks to Devi for all her support during the early years of my artwork. Also to Stuart Booth, my publisher, for his encouragement; and to Grace, my close friend, for her loving support while carrying out this book. I am especially grateful for, and appreciative of, the Foreword by Rhiannon Evans, a noted designer of Celtic gold jewellery, which she produces at the Welsh Gold Centre in Tregaron, Ceredigon, Wales.

Finally, to those Celtic design enthusiasts worldwide who have expressed appreciation of my work, may the recent widespread resurgence of Celtic craftwork continue to contribute its unique and uplifting beauty to our planet.

A special mention for Polly, my faithful sixteen-year-old canine companion, and the trusty Epiphone guitar, which has been my close friend for a number of years on this fascinating and exciting journey.

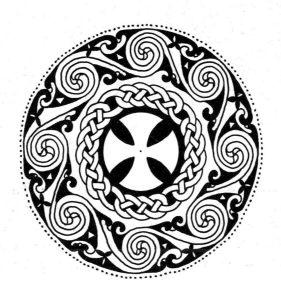

Index to Designs

The numbers given below refer to pages.